Published by the Institute of International Visual Arts
(inIVA), 1997.

Institute of International Visual Arts
Kirkman House
12/14 Whitfield Street
London W1P 5RD

Published to coincide with the exhibition
Avtarjeet Dhanjal
8 August–20 September 1997
Pitshanger Manor and Gallery, Ealing, London.

ISBN 1 899846 11 5
A catalogue record for this book is available from the
British Library.

Edited by Peter Cross and Gilane Tawadros
Essay by Brian McAvera
Produced by Victoria Clarke
Designed by Maria Beddoes and Paul Khera
Assisted by Mark Hutchinson
Printing coordinated by Uwe Kraus Murr/Stuttgart
Printed in Italy

Front and Back Cover Images: Avtarjeet Dhanjal,
Open Circle, 1984–85 (detail) and *Aluminium Series*, 1974.

Funded by THE ARTS COUNCIL OF ENGLAND

LONDON ARTS BOARD

Avtarjeet
Dhanjal

institute of international visual arts

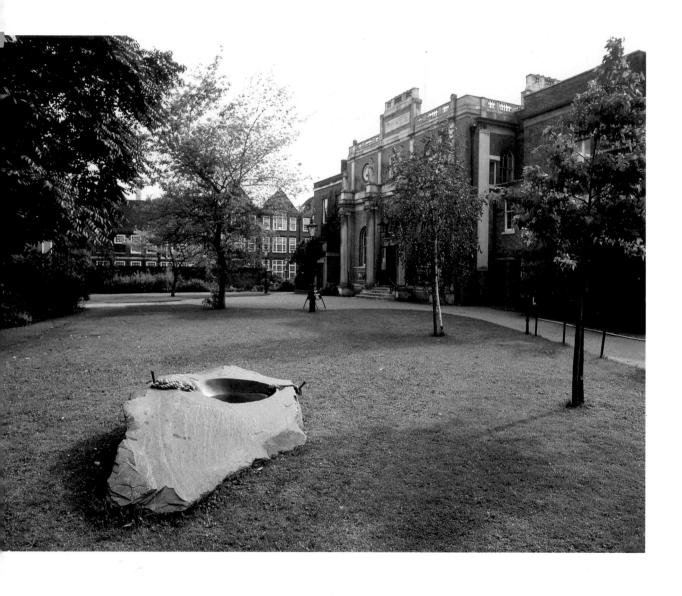

above. Avtarjeet Dhanjal, *Slate Series*. 1997. Exterior installation view at
Pitshanger Manor and Gallery, Ealing. Photo: Jerry Hardman-Jones.

Installation view at Pitshanger Manor and Gallery, Ealing.
Photo: Jerry Hardman-Jones.

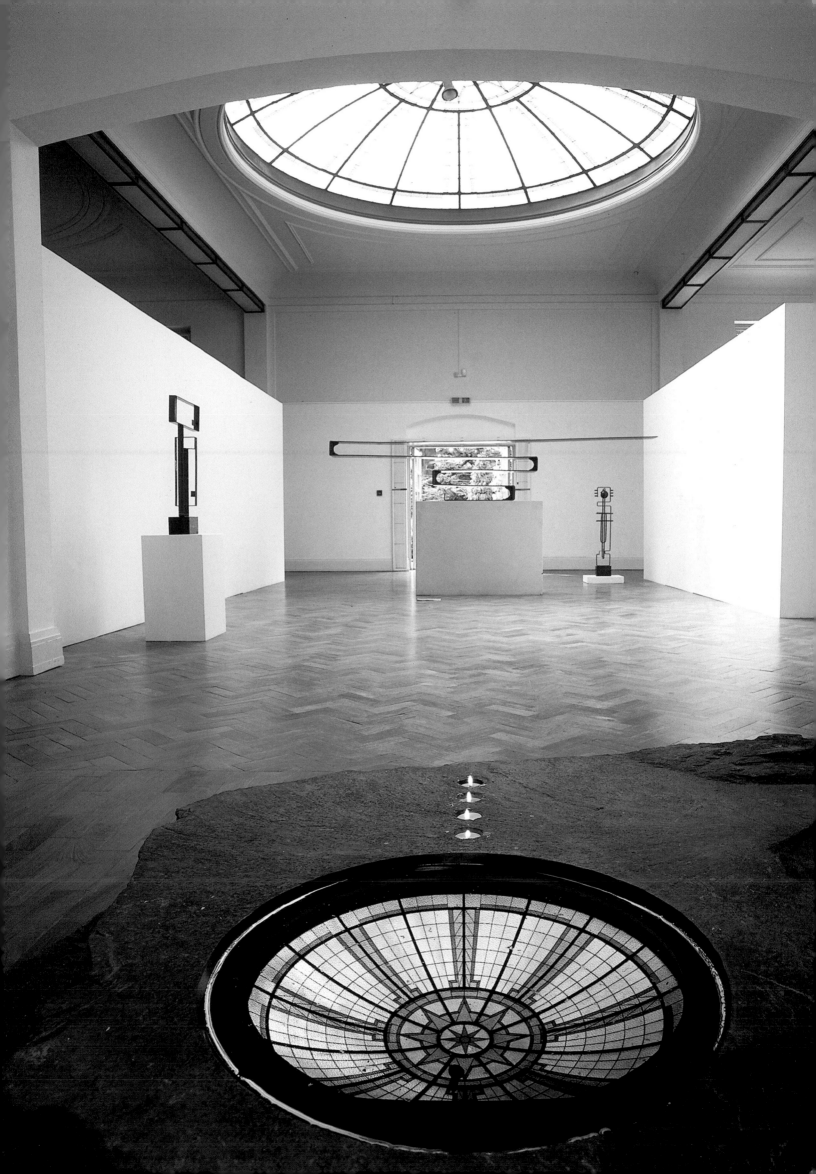

Foreword

Looking out from Avtarjeet Dhanjal's studio in Ironbridge where he lives and works, concrete cooling towers stand adjacent to dense woodlands, appropriately for a town which witnessed the first cold blasts of the Industrial Revolution. The tensions which are articulated in this landscape (and indeed throughout England) between nature and technology, between the rural and the industrial, mirror the poetic tensions in Dhanjal's sculptures between stillness and movement, aluminium and stone, fire and slate. Never resolved, opposing elements are held in suspension like the taut wire of a trapeze artist, stretched between two poles.

Born in Dalla in the Punjab, Dhanjal's personal and artistic journey has straddled many seemingly irreconcilable worlds. In 1947, his boyhood witnessed the creation of India and Pakistan and the end of British imperial rule over India. Hastily drawn up by departing British civil servants on maps they hardly recognised as more than diagrams of their own disappearing power, Partition created the biggest population exchange in modern history. In a century already characterised by global warfare and genocide, hundreds of millions of Hindus, Muslims and Sikhs lost their lives, homes and livelihoods. Partition drew a deep line between the rural, traditional village life of Dhanjal's childhood in the Punjab and his adult life, as a young man and student in the cities that were to shape the future of modern

India; in his case, Delhi and Chandigarh. Chandigarh, perhaps more than any other city in India, shows the extraordinary ambition of the new ruling class to transform the trauma of independence into an engine for modernity. Where New Delhi, completed only twenty years before Partition, maps out order, control, sanitation and above all a clear demarcation between imperial ruler and colonised subject, Chandigarh is the embodiment of an idea of the modern independent state. Designed by Le Corbusier, it is a grid plan for a new industrialised, self-sufficient democracy: a model, an arena opening into a future. New Delhi, like Buenos Aires or Budapest, speaks of Empire; Chandigarh, like Brasilia or Canberra, is an articulation of an abstracted idea of democratic government: a concept, something new, clean and which denied the contradictions of the past.

The skills Dhanjal learned at Chandigarh's art school were, like the city itself, strangely truncated amalgams of internationalist disciplines and ways of seeing - secular, realist and academic. The post-colonial curriculum included dreary rounds of life-classes, life modelling and so on, the imitation of European 'Masters' with a grudging glance towards modernism. This modern academy perceived the traditional (inevitably specific, local and rural) as folkloric—a quaint dialect that had to be transcended in order to learn the global language of modernity.

But this new language was unfamiliar, compromised and under-resourced, patched together out of what was, and what could be. Dhanjal's first large-scale free-standing sculptures were made of welded sheet metal, built with the help of relatives in the workshop where they made agricultural tools, but they were exhibited on the newly-built terraces of a modern metropolis.

His own early work transcended the local, his artistic language could be spoken anywhere. Modernism speaks of travel, movement, perpetual change and reinvention. Dhanjal travelled to Africa, that was, like India, newly emerging from a long and violent colonial past. He secured a lectureship at Nairobi University. He continued to work in aluminium— itself a modern composite material, an abstraction of metals. The forms and rhythms of Africa, already such a fundamental grammar in modernism, were in a way perhaps already assimilated in his practice. After three years, he moved on again, invited to exhibit in London in May 1973. The following year, he moved to England permanently and began studying at Saint Martin's School of Art.

This monograph has been published to coincide with the first major solo exhibition of the artist's work, held at Pitshanger Manor and Gallery between 8 August and 20 September. It charts the artist's career from his art school education at Chandigarh and St Martin's through to this most recent work, his large-scale slate sculptures, and is the first comprehensive study of the work of one of the most important post-war British sculptors. The exhibition and monograph have involved the co-ordinated effort of many individuals. We would like to thank all those who have contributed their time and expertise and especially the following: David Chandler, Valerie Chang, Victoria Clarke, Richard Cork, Jerry Hardman-Jones and Rob Sara, Mark Hutchinson, Paul Khera and Maria Beddoes, Juginder Lamba, Andrew MacKenzie, Brian McAvera, Rohini Malik, Ariede Migliavacca, Partha Mitter, Nima Poovaya-Smith, Neena Sohal and Carol Swords. Finally, we would like to thank Avtarjeet Dhanjal for his extraordinary energy, commitment and generosity at every stage of the project.

Peter Cross, Head of Exhibitions and Publications
Gilane Tawadros, Director

Author's Preface

There is little that has been written on Avtarjeet Dhanjal, much that has been written on some Asian artists in relation to *The Other Story*,[1] and little on the complex cultural specifics of first-generation Punjabi artists who have been domiciled in England. As an Irishman living in Northern Ireland (and therefore colonised and also British) I hope that I have some 'feel' for the cultural complexity involved. This essay is both a biographical and critical account of the artist Avtarjeet Dhanjal who came to England in 1974. Together with the retrospective exhibition organised by the Institute of International Visual Arts, it aims to reaffirm the quality of his work and his status as an artist, which have been largely overlooked by the English art establishment.

It needs to be stressed from the outset that the major object of this enquiry is the work itself. When Dhanjal, who is from a Sikh background, was included in the pioneering survey of Afro-Asian artists in post-war Britain *The Other Story*, the context within which his work was presented was necessarily limited. Unlike many of the other participants, he did not produce issue-based work and was marginalised as such.[2] It is a striking fact that, of the scores of reviews and articles which the exhibition attracted, not one discussed Dhanjal's work in terms of the work itself. To understand the sculptor's *œuvre* it is advisable to situate it within a complex palimpsest of narratives. These narratives should include the story of traditional Indian art;

the belated rise of Western modernism in the twentieth century on the Indian sub-continent; the neo-colonial legacy of art-schools in India, especially that of Chandigarh; Punjabi culture and its violent schisms in the wake of Partition in 1947; and Indian and especially Sikh concepts of religion.

More personal narratives would include Dhanjal's upbringing in a Punjabi village; his various occupations before becoming a mature student in the art college of the new city of Chandigarh which was—significantly—designed by Le Corbusier; his voracious acquisition of Western modernism which, to adapt a phrase from Apollinaire, he poured down his throat in a frenzy of acquisition; his three-year exploration of the African experience; the traumatic encounter with St Martin's School of Art in London and its all-too-specific metropolitan critical context; the confronting of his identity within the displacement of countries and cultures; the return to his roots; and finally the remarkable efflorescence of public art works, leading inexorably to his *pieces des resistances*, the slate works.

I should add that the precise disentangling of the chronology of the works posed a major problem. Not surprisingly, in the wake of his many journeyings and relocations, not to mention a habit of mind which gives little importance to documentation, the artist does not possess a

detailed curriculum vitae, much less a systematic filing system. Therefore, with the exception of the public works, it should be noted that the majority of dates are conjectural on my part, albeit usually accurate to within a three-year timespan.

Broadly speaking, the sculptor's development falls into three stages: from his art-schooling at Chandigarh, to his first pinnacle of perceived sucess, the years in Africa; the St Martin's experience and the rediscovery of his roots, culminating in his organization of a sculpture symposium in the Punjab in 1980; and the development of his major public sculpture, with its concomitant 'private' exploration, the slate works.

Many people have granted me interviews. I would like, in particular, to thank those who guided me through the cultural minefields: Pritam Singh, Principal Lecturer in Economics at Oxford Brooks University and his wife Meena Dhanda, Lecturer in Philosophy at the University of Wolverhampton, graciously granted me an extended interview,[3] particularly in relation to Punjabi identity and recommended many useful texts;[4] the sculptor Juginder Lamba, who was also the Director of the South Asian Contemporary Visual Arts Festival between 1991 and 1994, spent a long afternoon guiding me through the South Asian experience in England,[5] gave me many useful catalogues, and also loaned me an unpublished collection of essays on contemporary British art by artists of South Asian descent;[6] two friends of the artist were very helpful: the painter Ranbir Kaleka,[7] who went to Chandigarh art college in 1970 (the year Dhanjal left) discussed the college with me, as well as alerting me to the importance of Le Corbusier; and the sculptor Kanwal Dhaliwal[8] who was at Chandigarh art college between 1979 and 1984, discussed the art school background as well as the problems of cultural displacement; the Czech artist Peter Fink, who has been a friend of Dhanjal's since the St Martin's days, discussed the St Martin's experience and continually alerted me to useful areas that I had overlooked;[9] Frank Martin, course director of St Martin's when Dhanjal was there, and who is writing the authoritative survey on the college, not only gave me a telephone interview at very short notice[10] but also sent me some useful material; the playwright Raminder Kaur gave me a copy of her play about recent Punjabi history, *Bullets through the Golden Stream*[11] and also recommended many useful texts; C.B. Watson and Stefan Giggs, the Cardiff stonemasons who worked on some of Dhanjal's slate sculptures guided me through the practical processes of their work;[12] and the Board of the Punjabi

Institute were kind enough to let me sit in on a Board meeting, and afterwords pick their brains about Punjabi identity. David Chandler who brought me into this project, was enormously supportive, as were various members of the Institute of International Visual Arts, especially their librarian, Ariede Migliavacca, who supplied me with numerous books and magazines. But, in particular, I should thank members of the artist's family (his son, two daughters and his ex-wife) for a long interview, as well as the artist himself who allowed me access to him (I think he regarded it as an interrogation rather than an interview), firstly over an eight-day period and then over a further two-day period,[13] as well as shepherding me around many of his public sculptures. He also allowed me to ransack his house and decamp with quantities of his papers, books and slides. I hope he feels it was worth it.

I am additionally grateful to Pritam Singh, Juginder Lamba, Ranbir Kaleka, Peter Fink, Raminder Kaur and Avtarjeet Dhanjal, all of whom read the first draft of this book and saved me from many errors of fact. All remaining errors are, of course, my own responsibility.

Ploughing the Stars by Brian McAvera

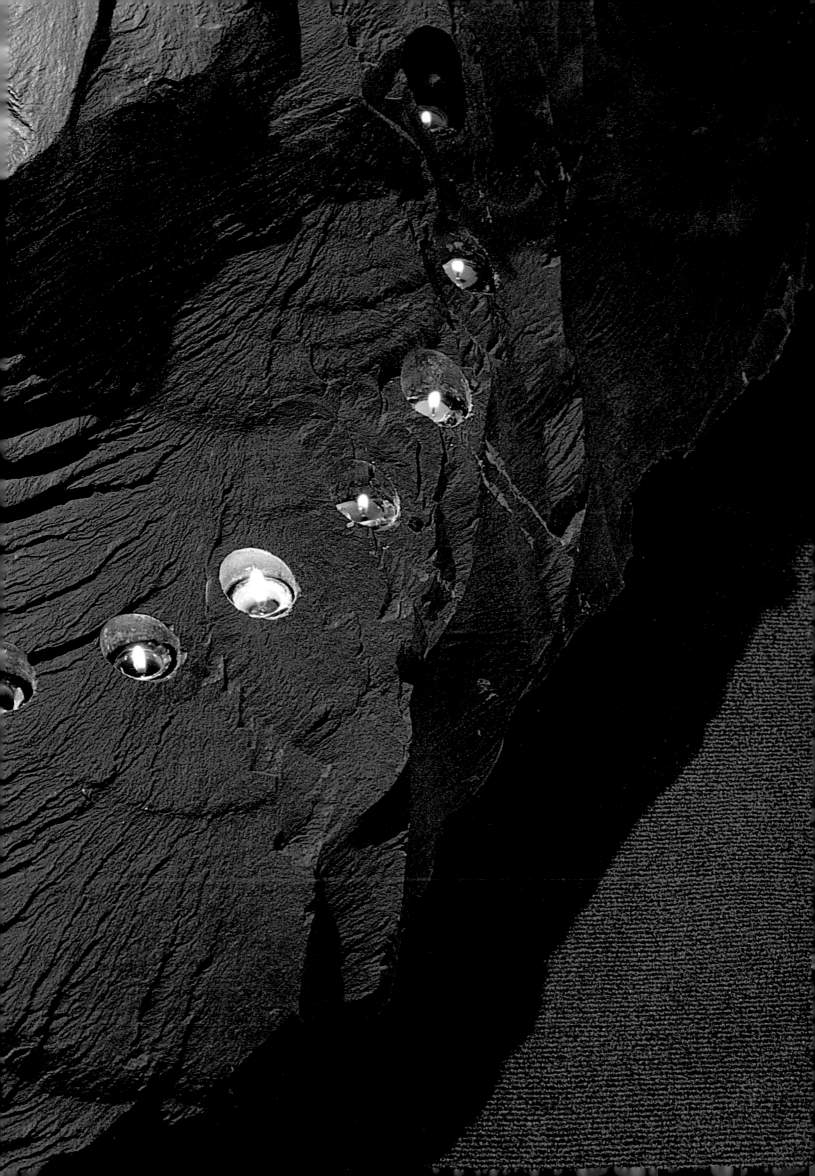

Art School

Avtarjeet Dhanjal attended Chandigarh art school from 1965 to 1970. Between 1963 and 1965 he had worked as a signpainter, which provided his livelihood, but he also produced paintings, designs for book covers, illustrations and covers for monthly literary magazines, including those for short stories by Kirpal Sagar. He also investigated where the art schools were. The one in Shantiniketan which had been set up by Rabinranath Tagore (regarded by many as the founder of the modern tradition in India) was in Bengal, and so too far away.[14] There was one in Delhi, and one which had moved from Shimla to Chandigarh, the new capital of the Punjab.[15]

Chandigarh, 'the first new city in the country since Jaipur', founded in 1728, was a modern city with a vengeance, and not only in comparison to the unplanned townscapes of other areas of the Punjab. Designed by Le Corbusier, the city could be described as the quintessence of modernism. In the wake of Partition in 1947, and 'one of the biggest and bloodiest migrations of people in history', it was decided that the Punjab should have a new capital.[16] The victorious nationalists quite deliberately chose to import foreign culture rather than assert the indigenous one. As a result, Le Corbusier (with his collaborators Jane Drew and Maxwell Fry) took the job, asserting that their task was 'to discover the architecture to be immersed in the sieve of this powerful and profound civilisation and the endowment of favourable modern tools to find it a place in present time'.[17]

This was a laudable aim, and comparable to Dhanjal's quest (and that of other Indian sculptors) to discover a sculpture that was applicable to the present time. Whether Le Corbusier succeeded is the subject of considerable and often rancorous argument. What is not in doubt is that he delivered a city based on a grid plan that is like a translation of a Mondrian painting. As the painter and sculptor Kanwal Dhaliwal noted, Indian architecture is in harmony with nature whereas that of Le Corbusier with its insistent verticals and horizontals, cutting the city into blocks, was not. The effect on people coming from a small village was substantial. 'You are instantly fascinated by the outside view: cleanliness, the pure colours (red, blue, green and yellow). Even the doors were in these primary colours. From a distance it appears like a painting. When you live in it, it divides people from each other'.[18]

As Ranbir Kaleka phrased it 'visual modernity was all around us'. He noted that there was a distinct difference between the internal and the external. Unlike traditional towns and cities, the wide, straight roads were routes to somewhere, rather than meeting places; and the housing and shopping areas were separated rather than integrated. This division and separation 'took away the liquid fluidity of mixing people, made one more individualistic, and made the idea of modernity acceptable and attractive'.[19] The city did, however, have many functional shortcomings.[20]

right. Avtarjeet Dhanjal, *Sculpture A*. 1968. Plywood. Chandigarh.

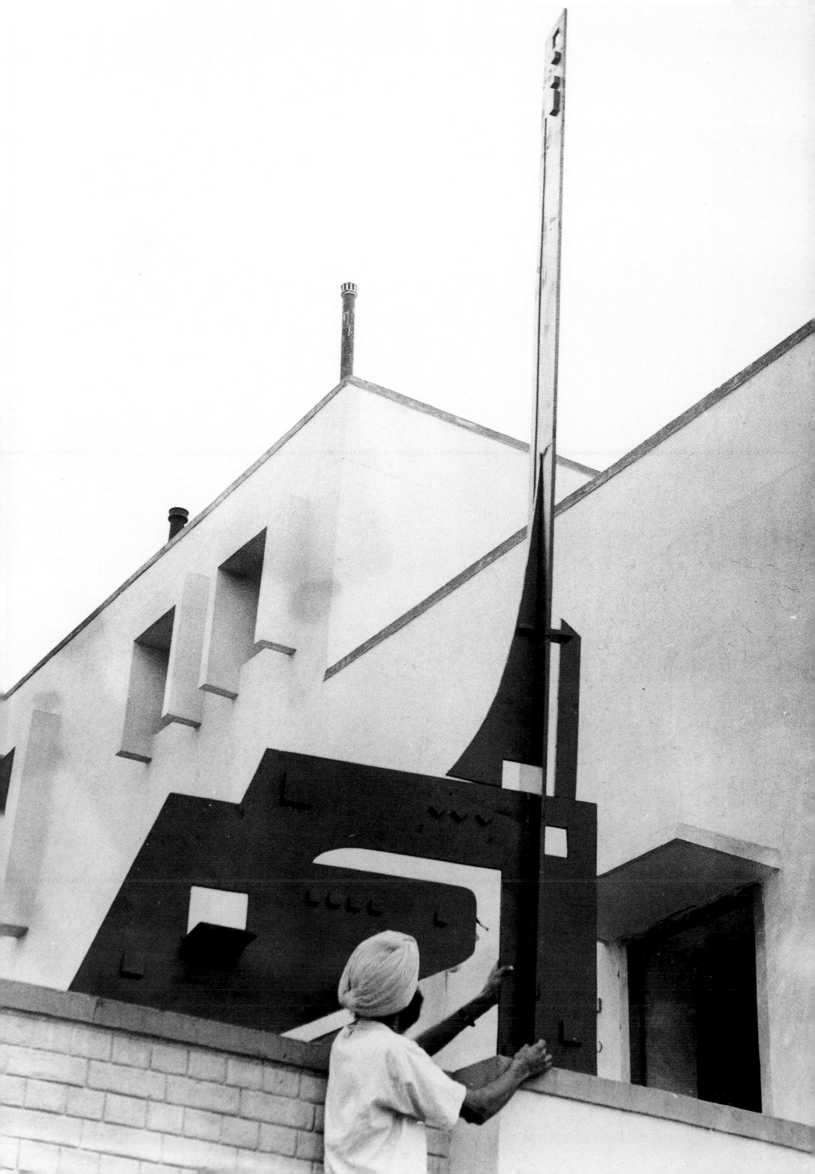

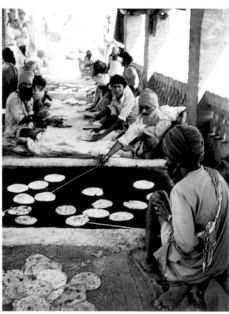

above. Scenes from the Punjab. Photos: Avtarjeet Dhanjal

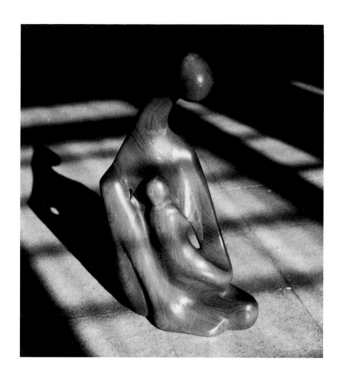

top left. Avtarjeet Dhanjal, *Mother and Child*. c.1966-67. Pine wood.
Collection of Chandigarh Museum.
top right. Avtarjeet Dhanjal, *Magazine Cover for 'Kavita'*. c.1961. Pen and ink.

below left. Avtarjeet Dhanjal, *Magazine Cover for 'Surtall'*. c.1963.
Pen and ink.
below right. Avtarjeet Dhanjal, *Two Figures*. c.1966-67. Pine wood.

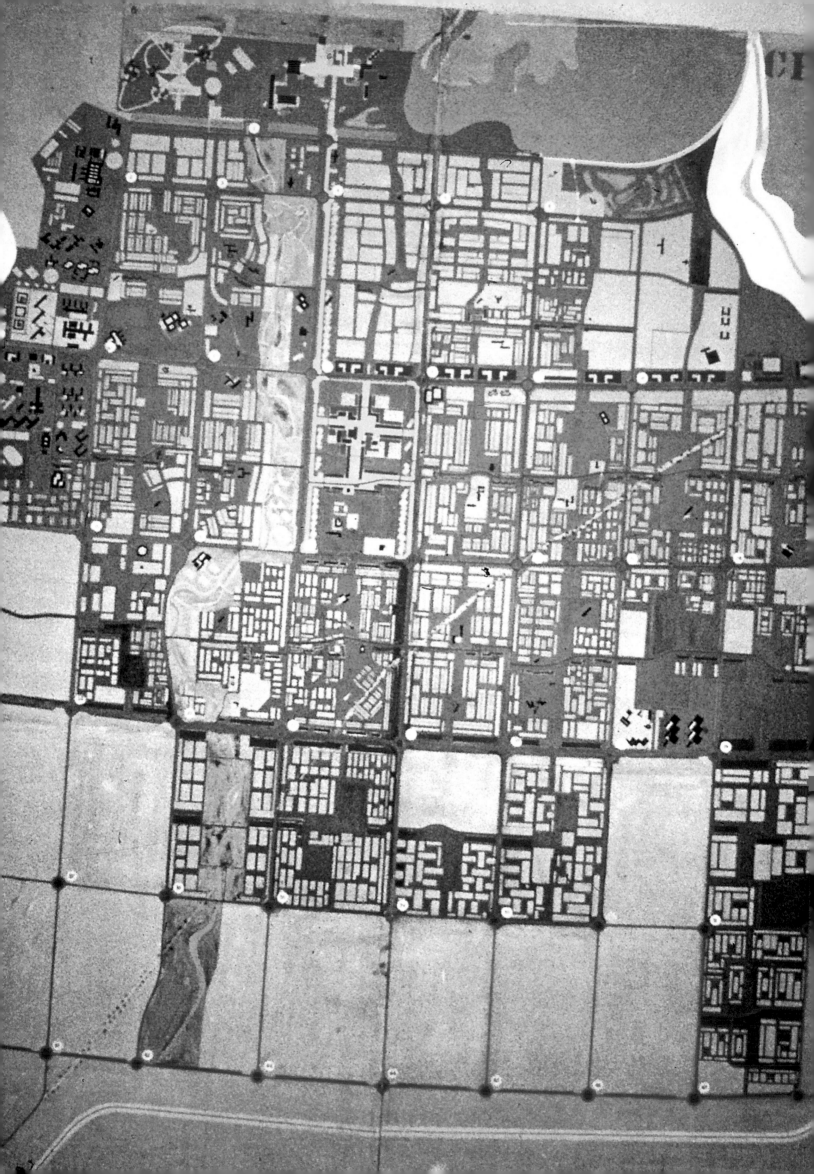

The 'visual modernity that was all around us' clearly reinforced Dhanjal's interest in modern art. It appealed to his desire to be urbanised yet allowed him access to the immediate countryside. But there was a dislocation *en route* to modernism, and surprisingly it took the form of Chandigarh art college where as Kaleka noted, the city itself was never discussed.

Dhanjal was a mature student of twenty-five when he arrived at Chandigarh, already earning enough money as a signwriter to support his wife and family of two (a daughter having been born), and still have a little left over. His expectations must have been enormous, but the reality was rather different. He actually went to study painting but in the first week of the two-year Foundation Course he had to do clay modelling. 'I thought the clay was for making pots but then I saw all of these objects..[other students' work]..all I could think of after that was sculpture'.[21]

Foundation meant Painting, Applied Art, Sculpture and Graphics. Sculpture consisted of clay modelling and plaster reliefs and little else. One drew from casts and from the model in a realistic vein. Tutorials were non-existent — two in five years according to Dhanjal. There was little attempt to get the students to explore. Indeed even the library, seemingly a good one, had so many rules and regulations that the students rarely used it. In art history 'a man read once a week from a book, or his notes. There were no slides or prescribed texts'.

Kaleka, who attended from 1970 to 1975, emphasises that no intellectual framework was provided for students unlike, for example, the Baroda School of Art, and that the tutorial system was extremely limiting, even damaging. There was 'no attempt to question'.[22] Dhaliwal, who attended from 1979 to 1984, reinforces these comments, emphasising the superficiality of the teaching. 'Neither students, teachers nor administrators were serious about the original aim of the college which was to create an awareness amongst students of the cultural and artistic background of our country and of the world'.[23]

In this hangover of the colonial attitude, a college where bad teaching flourished, where Indian art and culture were ignored, where art history was cursory, and where practical techniques were in short supply, Dhanjal flourished, probably because he was a mature and determined student who had an independent mind. It is clear that he swiftly realized that self-help was the best option. Within a short time he had rented a garage as a studio, and a pattern developed. As the college did not teach either wood or stone carving, he would work at both of these in his studio before going to college. Every two weeks he would return to his family, and in the long summer vacations as well as all other holidays, he would work fourteen hours a day at signwriting, so as to pay his way.

Working in clay and plaster seems to have come naturally to the artist. All of his works in the college, whether carved in wood or stone, or constructed out

left. Chandigarh City Grid System.
above. Chandigarh Museum.

17

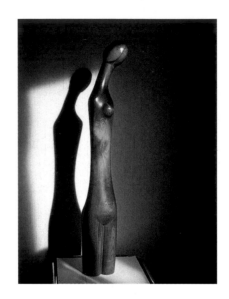

of metal, were first drafted in clay or plaster. The first sculptures, which were seated or standing figures, slightly abstracted into faceted geometrical planes, had a pronounced organic and rhythmical feel to them. They were probably translations of the style that he had developed in his magazine and book covers.

Carved wood obviously has a very long tradition in India, wood being in general use functionally and architecturally. Dhanjal would have been well aware that the limitations imposed by the medium itself would naturally lead to vertical/columnar designs, or to reclining figures—which are, of course, what he produced. He may well have seen the work of Indian artists such as the sophisticated, undulating or spiral-shaped sculptures of Sankho Chaudhaury, or the stylized distortions of Dhangraj Bhagat[24] who elongated proportions, and turned body-joints and sharp angles into organic curves. Both of them appreciated the wood-grain itself, and exploited fluid contours and smoothly-flowing surfaces.

But the new was rapidly gaining the upper hand. Dhanjal was becoming ambitious both in terms of materials and scale. He was still making small maquettes, usually in plaster, but now he was translating them into large-scale steel abstractions.[25] He was looking at artists like Alexander Calder and David Smith, and it was in March 1968 that the Indian art magazine *Marg* obligingly produced an issue on world sculpture. Even earlier, in 1966, the British Council had toured an exhibition of the British

wunderkids of fifties and sixties sculpture, the illustrated catalogue essay being reproduced in the magazine *Lalit Kala Contemporary*.[26] As Dhanjal was in Delhi at the time he may well have seen the exhibition or read the magazine article.

By 1969 the artist had produced a 17–foot high sculpture in plywood (he couldn't afford to make it in steel) inspired by Le Corbusier, and a series of works in aluminium. He had been to a market where he saw aluminium strips which had been cut for flooring. He bought some, folded them with pliers, painted them red, and the result was the first of a series of works in this medium.[27] These slim and simple icons of modernity, looking uncannily like a prefiguration of the St Martin's style which he would encounter when he became a student there in 1974, were soon to be developed, but in Africa.

Sometime in 1966 a Swiss tourist had visited the college, showing Dhanjal a postcard of African Tribal art. A special issue of *Marg*, devoted to African art, intrigued him. He had relatives in Kenya. In three years time he would be sailing for the African continent. And so in January 1971, having finished his five-year course at Chandigarh, having sold work to Chandigarh Museum as well as to the Lalit Kala Akademi in Delhi, he set sail for Kenya, equipped with a range of technical skills, an eclectic vocabulary of modernistic forms and the urge to move forward.

He also had a set of pen and ink drawings of Indian temples, done when he was on an art college trip to

above left. Chandigarh Art College (interior).
above right. Avtarjeet Dhanjal, *Virgin*. 1966. Private Collection.

right. Avtarjeet Dhanjal, *Woman Combing Her Hair*. 1966. Clay.
Installation view in front of Chandigarh Art College.

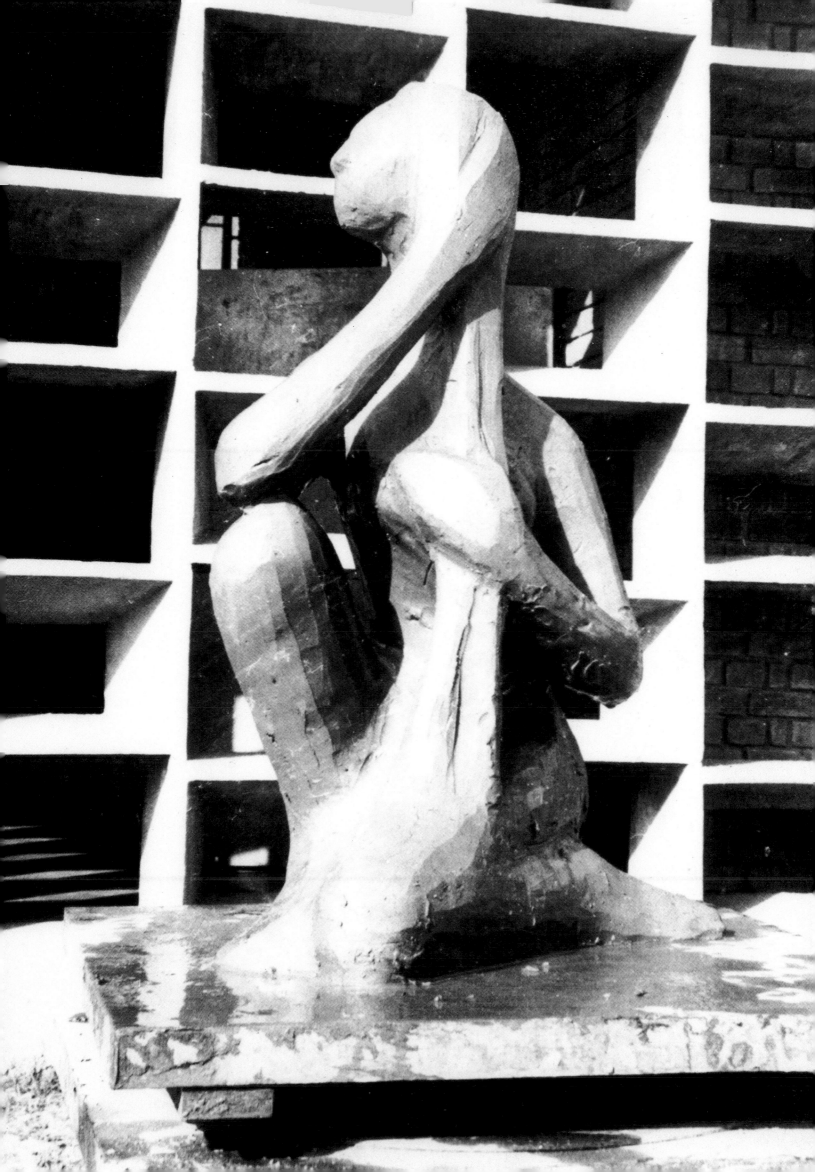

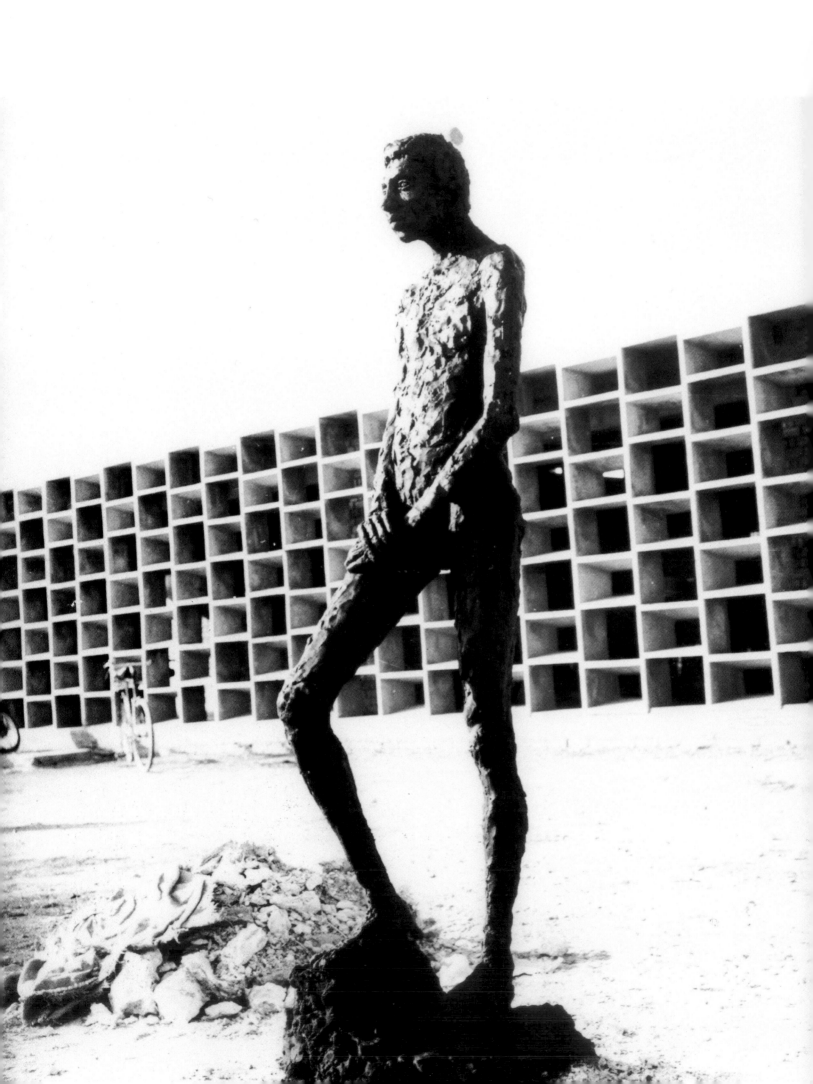

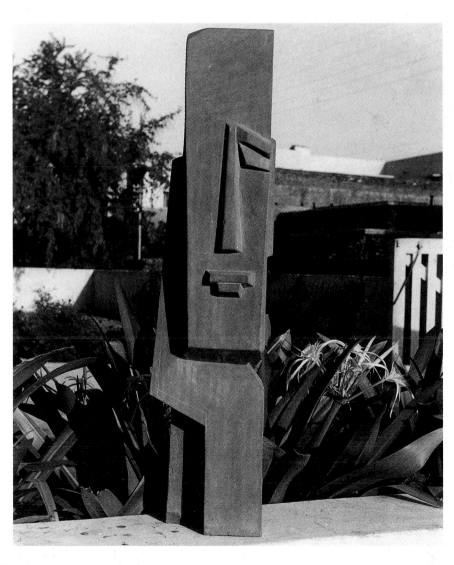

left. Avtarjeet Dhanjal, *New Life*. 1968. Concrete.
Installation view in front of Chandigarh Art College.
above. Avtarjeet Dhanjal, *Untitled*. c.1967. Red stone.

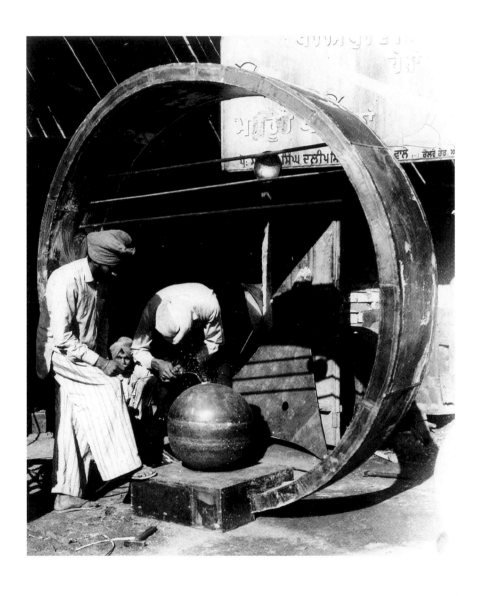

above. Avtarjeet Dhanjal, at work on *Conquest of Space*. 1966. Painted steel. (Work bought for the collection of Chandigarh Museum, 1969). right. Avtarjeet Dhanjal, *Untitled*. 1968-69. *Steel*.

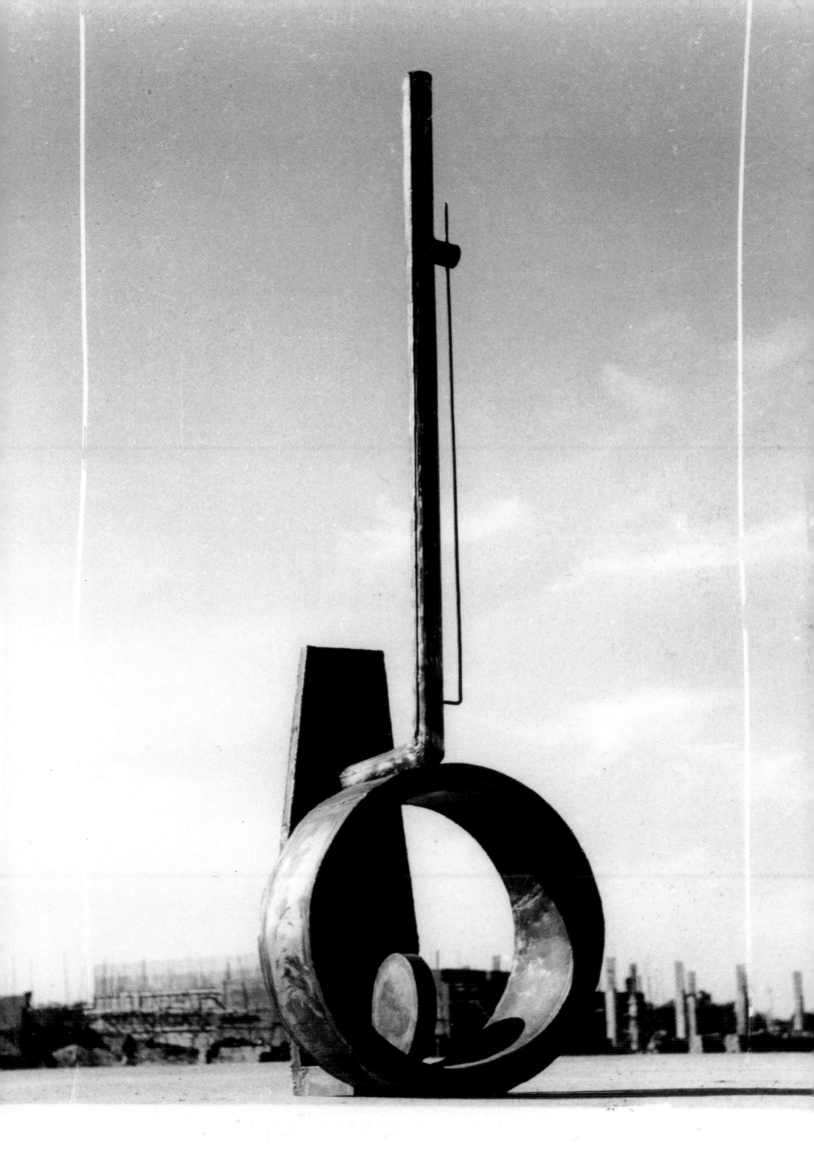

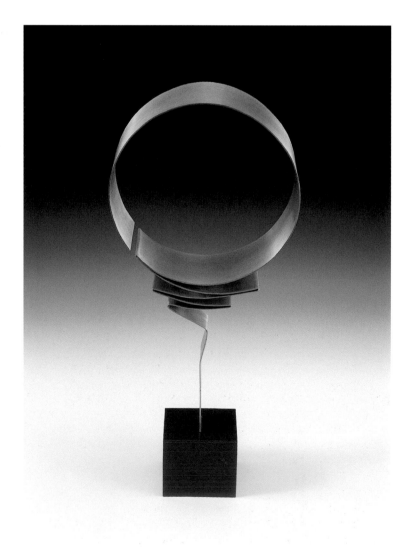

above. Avtarjeet Dhanjal, *Painted Aluminium Series*. 1969. Chandigarh.
below. Avtarjeet Dhanjal, *Aluminium Series*. 1969. Chandigarh.
Photo: Jerry Hardman-Jones.

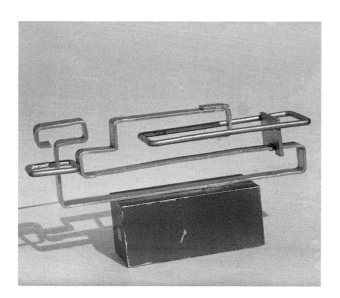

Central India several months earlier. He boarded ship at Bombay, unaware that one changed money in a bank beforehand. To survive he sold drawings in the dining hall and also quick pen-and-ink portrait sketches of passengers. Arriving in Mombassa, he travelled for several months, visiting Tanzania, Malawi, Zambia and Ethiopia before returning to Kenya. In between he taught for a few months in a private art school and then, in July, he became a lecturer at Nairobi University.

If this sounds a trifle surprising for a recent art college graduate, it is nevertheless true. In Kenya 'things worked very much as in India' with the result that an English gallery owner who liked him, made a connection to an official in the Ministry of Education who liked the artist's work; a state-of-affairs which was reinforced when the artist gave him a wood carving.[28] Shortly afterwards he was offered a lectureship as one of the teachers was retiring. For at least a year he took it easy. It was in the nature of a recuperation. The Indian college 'hadn't taught me to develop my thinking processes'. Nor was he articulate enough, or knowledgeable enough within the university situation to discuss Indian art, but he was enthusiastic, and he did possess technical knowledge and a continual curiosity.

Eventually he decided to make new work. There was a company in the neighbourhood which made double-glazing units in aluminium. Naturally there were lots of offcuts which he could use: 'the work grew from that availability'. Gradually the sculptures

mutated from a small-scale spare and simple calligraphic linearity into a complex, often sinuous muscularity, which sometimes acquired figurative overtones. The siting of a number of these, as revealed in the artist's photographs, indicates that the natural world was never very far from his mind.[29] Despite the seeming coldness and industrialism of the material, Dhanjal's sculptures work best when sited in the open air, set against the interplay of greenery, running water or weathered brick.[30]

Perhaps he felt that he had 'made it', now that he was a lecturer, an 'artist', a resident in another country. Whatever the truth, he had the urge to show in Europe.[31] A friend had a contact in England at the Woodstock Gallery so he sent photographs of his work, was offered a show, and went to London in May 1973. At the Gallery's suggestion he visited at Chelsea and St Martin's art colleges, and six months later he was to be a student at St Martin's on the Advanced Diploma course.

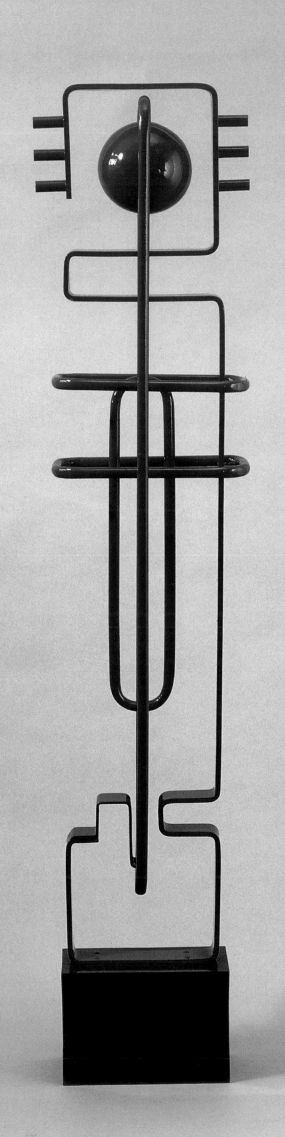

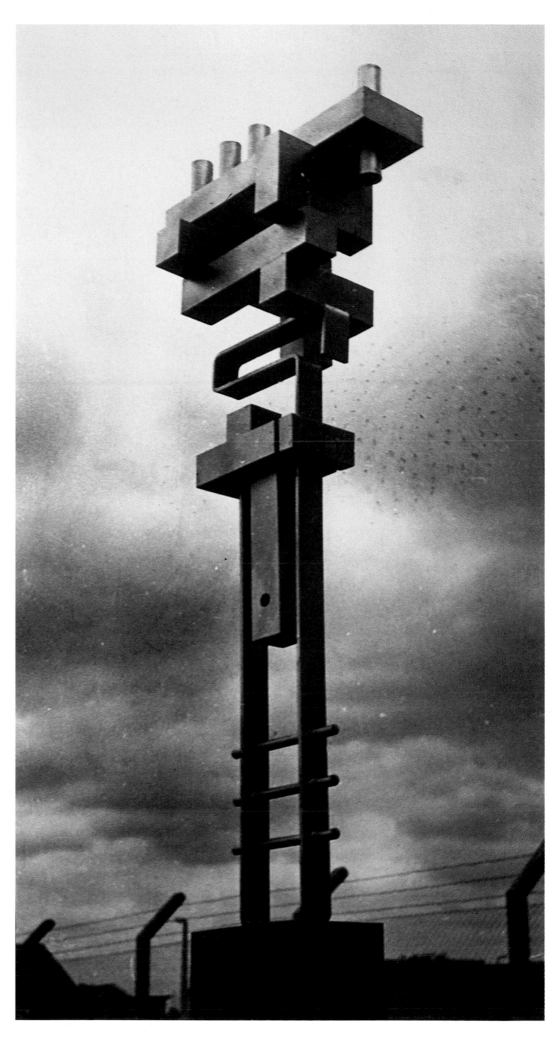

left. Avtarjeet Dhanjal, *Painted Aluminium Series*. 1973. Nairobi, Kenya. 27
above. Avtarjeet Dhanjal, *Aerial 2*. c.1973. Collection of Punjabi University
Museum, Patiala, India.

House and Community

Two elements were required before Avtarjeet Dhanjal, the mature student from the Punjab, would turn into Dhanjal, the mature artist. Both of them related to his upbringing and heritage. Firstly he had to relearn the essential communal and community spirit of his village which would manifest itself eventually as Dhanjal, the catalyst for change in the community. Not only would he form the Punjabi Institute, set up students' and teachers' exchanges between the Punjab and Shropshire County and the Shropshire Millennium Project, and form artists' organizations such as Artists' Concern and The World Beyond 2000 but he would also act as trustee for the South Asian Visual Arts Festival,[32] the Visual Arts Trust in Shropshire, Sampad (the Asian Arts organization in Birmingham) and the Public Art Commissions Agency in Birmingham, not to mention being a member of the West Midlands Arts Board and an Advisor on their Visual Arts panel.

Secondly, this reintegration into communities needed to be accompanied by the artist finding a bridge between Western modernism and Eastern religious philosophy. Dhanjal achieved both of these elements but the journey towards them—elements which would manifest themselves from 1980 onwards, in his major public art works and in his slate sculptures— only began in earnest with his study trip to the Punjab in 1978, the purpose of which was to explore Punjabi folk heritage.[33] The period 1974 -1980 was crucial to the artist's development: it laid the foundations for all of his subsequent activities.

Indisputably, English culture had a profound effect upon the artist. Initially he saw it through the lens of St Martin's School of Art. In the period following the *New Generation* exhibitions of 1964 and 1965 which showcased the sculptors Scott, King, Annesley, Tucker, Witkin and Bolus, all of whom had studied under Anthony Caro at St Martin's in the fifties before returning to teach as his associates, the Sculpture Department there was established 'as a magnet for virtually any ambitious young aspirant'.[34] By 1970-71 the teaching was based essentially on sculpture made in steel and 'springing from Caro's mature work'.[35] By 1974 it was 'already in decline and an orthodoxy was made out of openness'.[36]

It seems likely that Dhanjal, who arrived in January of that year, came with financial expectations, assuming like many Third World students that it would be a passport to instant success; and unaware that only a small proportion of students would survive. As a mature individual, an ex-university lecturer in Sculpture, and an artist from another culture who was already equipped with an extensive vocabulary of abstract forms, he may have thought that integration, and development, would be easy. Was he not already doing work which bore superficial similarities to the St Martin's style?

But it was to be 'a bruising experience'. He 'didn't fit in'.[37] Close inspection would rapidly show that his sculpture was very different from either Caro's or that of the Caro acolytes.[38] Their ground-hugging tendency was alien to him (rather he aimed for

right. Avtarjeet Dhanjal, *Aluminium Series*. 1974. St Martin's.

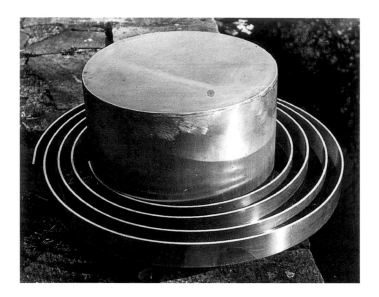

verticality) and while they were making a dogma of stripping away all associations, producing spare, often dryly elegant pieces in welded steel, Dhanjal was instinctively replacing his own subliminal figuration with ideas about Nature, and Caro's linearity with a fluent curvilinearity. Dhanjal's sculpture was neither constructed nor decorative and he had ambitions to incorporate movement. Furthermore, he didn't really feel comfortable in steel but was drawn to aluminium, a material which he already knew well.[39] To use one of his phrases he was 'dis-anchored'; was 'failing to fit into their mould'.

St Martin's was full of intellectual theory, from William Tucker amongst others, which the pragmatic and instinctive Dhanjal distrusted.[40] For him, the place was interested in foreign students but didn't know what to do with them. He felt that none of the lecturers knew anything about Indian art and most of them weren't interested, or didn't realize, that he was coming to them with a different set of cultural assumptions and ideas. Put simply, they weren't interested in (or perhaps weren't capable of) helping him to find a solution to *his* problems unless it was viewed through a Western perspective.[41]

If one attempts to look at the situation from a St Martin's point of view, under the course leader Frank Martin, they were providing him with studio space for a year, regular 'crits', access to tutors and lecturers and the luxury of working on his own work. They would have discovered swiftly that he 'had no competitive reality', lacked any background in American painting and theory (Noland, Greenberg, Fried, et al.), may well have assumed (incorrectly) that he would understand the typical phases of negotiation with lecturers, and doubtless never thought that the tough, forceful, indeed brutal stance of 'total questioning of what one was doing', as Peter Fink described it, may well have been interpreted as hostile.

Dhanjal thought that the prevailing ethos was remote, if not disconnected, from life and that critical and tutorial enthusiasm went almost exclusively to students whose works were affiliated to the prevailing ethos.[42] It is possible that this may have been reinforced by a conscious or unconscious response to him which was couched in racist terms.[43] Juginder Lamba, a Punjabi friend of the artist's who came to Britain from Africa, bluntly states that it was not 'until [he arrived in] Britain, that racial discrimination came to the fore....The door is only open so far for us...It makes you confront your identity'.[44] It is however also true that there was a considerable spirit of generosity in the college. When Dhanjal's money ran out after three months, leaving him nowhere to live, and he had to take a night-job at a glass factory, it was a part-time teacher, Peter Fink, who loaned him the use of a studio where he could sleep.

Obviously Dhanjal's identity as a Sikh, with its immediate visibility in terms of turban, long hair and beard, may have contributed to a sense of isolation; of feeling trapped in a culture which he had assumed would be welcoming. He was progressing the

above. Avtarjeet Dhanjal, *Aluminium Series*. 1974. St Martin's.

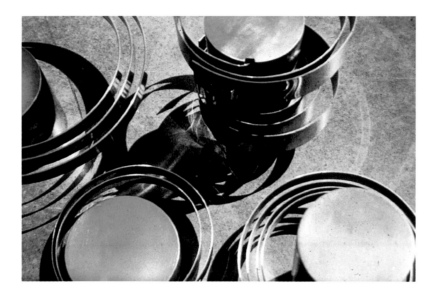

aluminium pieces which had started in Chandigarh, developed in Kenya, and came to fruition as large-scale public sculptures in Britain and elsewhere. Having explored the linear and the muscular, he was now moving decisively towards spiral formations, away from the technological look of the Kenyan pieces and towards a progressive simplification of his ideas. He realised that he had to liberate himself and pursue his own convictions. The British art scene appeared to him as if 'under a glass bowl, visually accessible but unreachable'.[45] There was only one logic for an independent spirit like Dhanjal's: to fight back; to ignore what he perceived as the establishment, and to develop without art-world compliance. So he did.

The development of the spiral aluminium pieces was rapid: small, and coiled spiral shapes, single and multiple, which were low-lying; then attached to a base, the top of which was brightly painted in a primary colour; then deprived of the colour and beginning to expand in size. As with the Kenyan pieces, they were often photographed against a background of natural stone or water. As various statements of the time make clear, Dhanjal was quite clear as to what he was doing, and what he wanted to do: 'My work is very close to nature (by its nature, not by shape), and has life like a tree or a plant. My pieces respond to atmosphere like natural vegetation (in contrast to man-made objects). They grow under the sun, breathe in the open air, swing like trees and vibrate like leaves. Watching my pieces takes the viewer into an environment of visual music'.[46]

He was also quite clear about the means: 'Movement and sensitivity in my work is based upon the elastic property of material, the same property that makes the leaves and branches of a tree flexible and sensitive to natural wind. Most kinetic sculptures....are fitted with computerised mechanical gadgets. The unnatural artificial movement..has no pace with the human temperament...One is inhuman and repeated..[the other is] natural and has endless variety. I prefer the second one in my work. In my pieces there is a sensitive balance between tensile strength and the force of gravity of the material used...aluminium has a low specific gravity and [good] elastic deflection'.[47] In other words, the elasticity of the aluminium combined with natural wind, should in theory produce perpetual movement.

There is little evidence that Dhanjal showed any interest in the Kinetic Art movement of the sixties except insofar as it was a development of Constructivism. He certainly knew photographs of the work of Alexander Calder but the leading kinetic artists, mainly Europeans or Latin American artists working in Europe, seemed to have passed him by.[48] For that matter, American art in general, and Minimalism in particular, also seem to have left little impact upon him.[49] And though it is true that Land Art came to have a major place in his work, the movement as such, in terms of artists like Michael Heizer, Robert Smithson, Christo, or even Richard Long, seems not to have influenced him.[50]

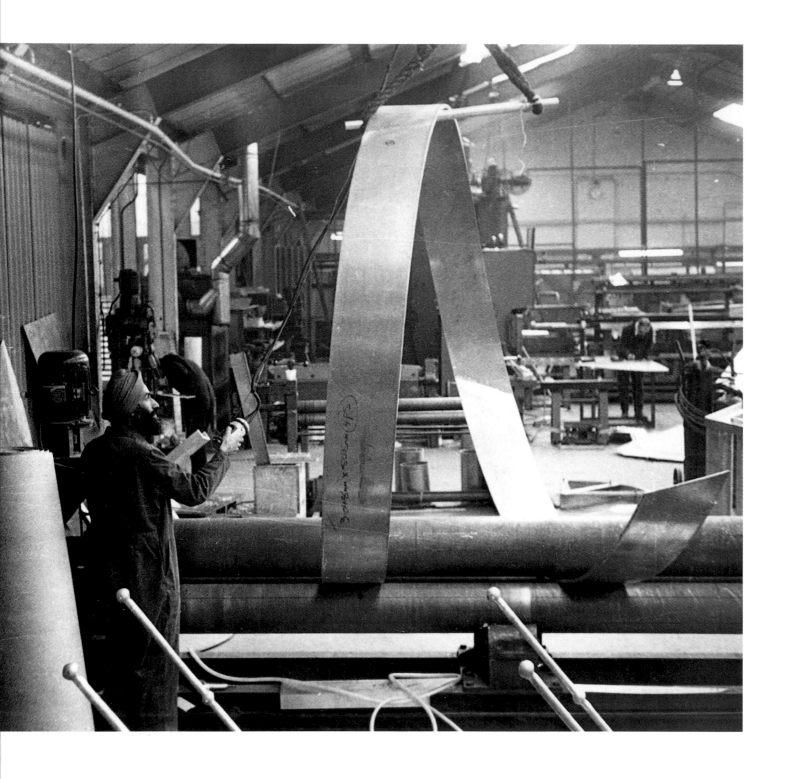

above. Avtarjeet Dhanjal at work at Alcan Aluminium (UK) Ltd. 1975.

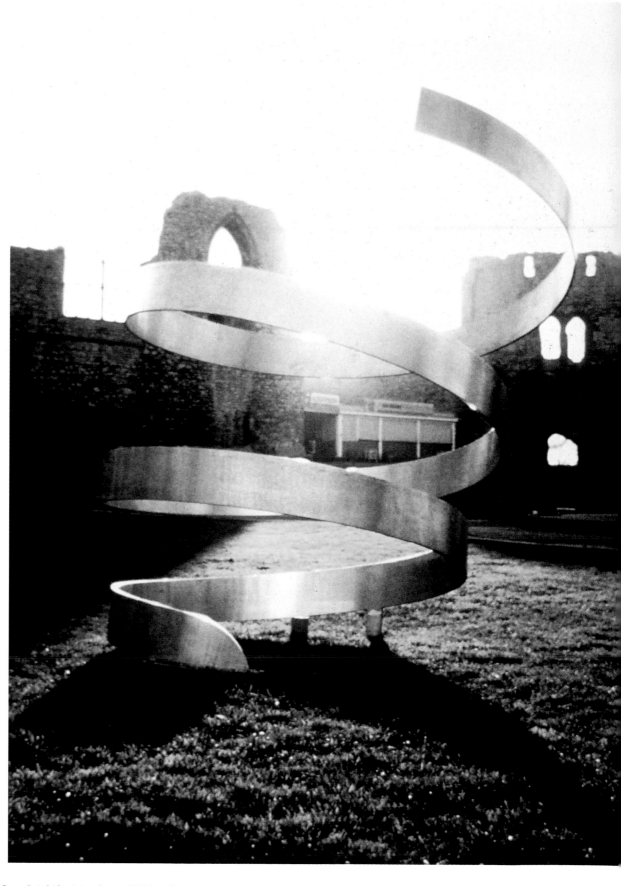

above. Avtarjeet Dhanjal, *Open Spiral Aluminium Series.* 1975. Installation
at Dudley Castle.

33

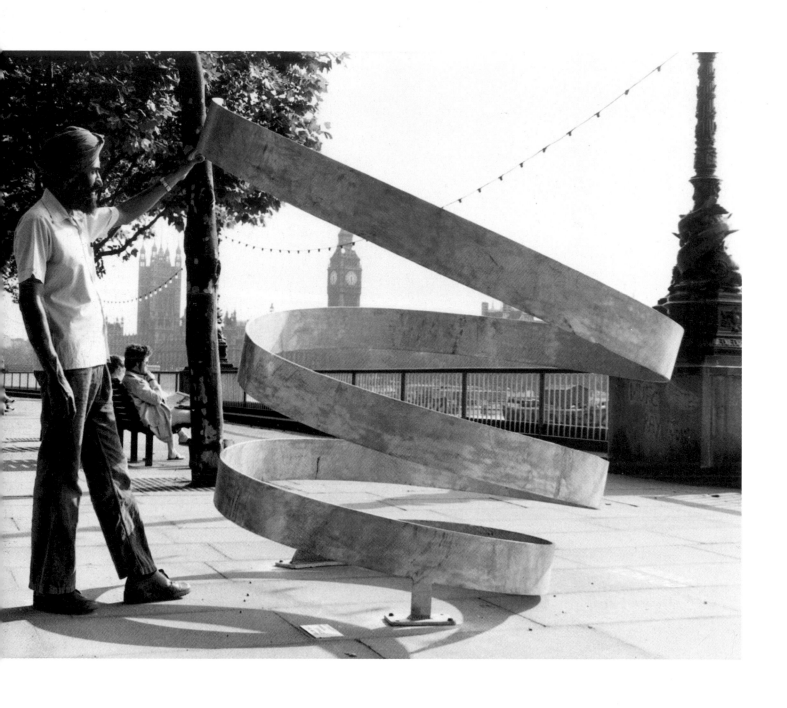

above. Avtarjeet Dhanjal and *Open Spiral Aluminium Sculpture*. 1975.
Installation at St Martin's South Bank Exhibition, 1977.

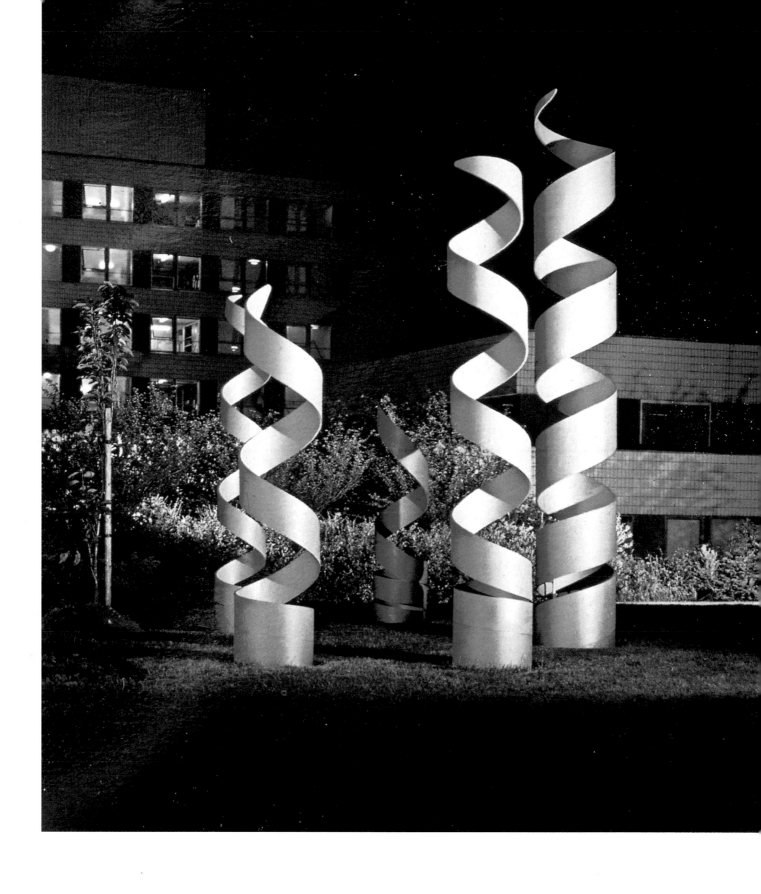

above. Avtarjeet Dhanjal, *Grown in the Field*. 1976-77. Installation at the
University of Warwick. Commissioned by Alcan Aluminium (UK) Ltd.
Collection of University of Warwick.

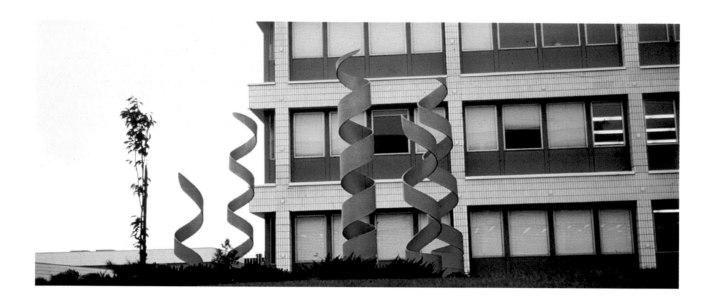

Towards the end of the year, the artist began to experiment with photographic works and with resin-based sculptures, which were exploring the natural environment, and so complementing the aluminium work.[51] At the same time, Dhanjal was actively pursuing opportunities to make and disseminate his work. He sent two of the small aluminium sculptures by post to Barcelona and had them accepted for the exhibition *Concurso Internacional de Escultura* in 1974, produced at least one coloured postcard of a photographic work, persuaded a film student to do a showreel of his small sculptures 'fluttering in the wind', and then approached Alcan Aluminium (UK) Ltd to sponsor a project for a group of large-scale, outdoor aluminium sculptures.

Dhanjal was ahead of his time in negotiating a relationship with industry: Alcan accepted, and from January to December 1975, primed with a substantial grant and superb working facilities, he seized his opportunity to work on an industrial scale. We know what he produced from photographs of an exhibition held at Dudley Castle in December of that year.[52] Unfortunately much of this work was destroyed though some of it was also exhibited at Gallery 27 in Kent in 1976 and at the St Martin's exhibition at the South Bank in 1977.[53] Dhanjal had seized the opportunity, not only to work on an industrial scale but also to explore the integration of art into the environment. There is a clear relationship between the photographs of the early aluminium work in Chandigarh, Kenya and St Martin's, mostly posed in natural domestic-scale surroundings, and these large

open-ended spirals, majestically posed in relation to crumbling castle walls, greensward and riverbank. The apogee of this development would come with the production of five new large-scale spiral pieces in 1977 which were made for Warwick University and sited in grassy landscape in front of the main university building.[54]

It is probable that Dhanjal was feeling dissatisfied on several levels. With the Warwick sculptures he had come to the end of a line of development. They were not sited as he would have wished, and indeed it is quite possible that, in terms of his ideas about integrating art into the community, and about connecting art to nature, he may have come to regard them as merely a partial solution. His travels in the USA the previous year had reinforced the negative conclusion that America 'wasn't a country' for him. Something was nagging away at him and it came to a head when he formed the first version of the Friends of Punjab, under which banner he would organize a study-tour to the Punjab. At Chandigarh he had spent five years studying but 'the description of art was very much Western since the School was originally set up by the British. There was never any mention of the folk art and crafts that existed in the villages from where at least seventy percent of the students came'.[55]

The only logical conclusion was to re-establish the link between himself and his heritage. Being the independent entrepreneurial spirit that he was, he did it in style. In Spring 1978 eight artists and

above. Avtarjeet Dhanjal, *Grown in the Field*. 1976-77.
Installation at the University of Warwick.

professionals including Dhanjal, two Polish architects, a Polish/British film-maker, a Scottish designer, a Czech photographer, an American sociologist and a Japanese sculptor whom he had met at St Martin's, all left for the Punjab. The tour 'was designed to gain a basic knowledge of folk art, crafts, and folk architecture of the Punjab, as seen from the diverse backgrounds' of the group members.[56] Bearing in mind the 'negative influence of technology on the folk art and crafts in the West... [they]...wanted to see the effects of growing technology on daily life and folk art'.

The study-tour report is evidence that Dhanjal was profoundly affected by the event. He himself was not an intellectual but he surrounded himself with individuals who would enable him to see his homeland from a variety of external perspectives. The group looked at art and crafts, finding weaving, embroidery, pottery, furniture-making and house-building. They observed both vernacular architecture and historical as well as contemporary architecture, and gleaned impressions of murals, painting, music and dance. The sculptor Hiroshi Mikami wrote a short paper about tools and techniques, while Dhanjal wrote a paper on 'Portals, doors and closets', observing how doors in the Punjab were left wide open so that people could always come in, how they were social spaces, often covered with elaborate reliefs and small sculptures. In particular the entrance portals to Jain, Hindu and Sikh temples were often highly decorated.

The following year, with the help of Peter Fink, Dhanjal moved to a basement flat in London and built a studio in the garden. He spent three to four months in Spain, taking photographs: images of leaves and interstices of branches seen against the sky; leaves floating and reflected in water; serried ranks of coloured and lit candles; still-lives of oranges and partially-filled glasses of water. He also started to produce sculpture, in this case three-dimensional equivalents of the photographs, using resin. There were low-relief panoramas, like three-dimensional Jackson Pollocks, made out of leaves in varying stages of life and decay, not to mention box-like constructions consisting of sections of branches, some laid longwise, some endwise, whether stripped of bark or not, embedded in resin or half-embedded in resin. These poetic transformations, using clear resin to create the transparency of water, were frozen photographs which enabled him to find his way back to art-in-nature after the dead-end of the large-scale aluminium pieces.[57] In the wake of the Punjab journey, it was as if he were freeing himself up for an arduous assault: how could he make major sculpture out of the quarrel between homeland and foundland?

Temple

Phase 1: Tradition and Technology 1980–1983

Much of what has been written on the sculptor seems to me to miss the point, or at the very least to be based on misunderstandings. Rasheed Araeen in *The Other Story* included Dhanjal as one of those 'whose beliefs can be located in the modernist aesthetic that postulates the idea of self-expression as its ultimate goal, while the idea of art itself is not questioned'.[58] Yet Dhanjal never sought to express his *personal* psychological and social self. And irrespective of whether it is essential for a modern artist to question the idea of art itself, it remains a fact that Dhanjal does not separate his 'art' activities from, say, his craft work or his committee work.

If Araeen seems to stress the Western as opposed to the Eastern, and to emphasise sculpture as the discrete free-standing object—without acknowledging Dhanjal's journey into the realm of Public Art as related to community engagement and a synthesis with nature and landscape—Shelagh Hourahane tends to overemphasise his Punjabi village identity at the expense of the sculptor's engagement with Indian culture more generally, (and in particular that of the temple tradition) and to downplay the public sculpture, arguing that 'it is for users rather than for viewers and has more relationship to the roles of architecture and landscape architecture than it has to the traditional role of the sculpture monument'.[59] Leaving aside the point that the traditional role of the sculptural monument had largely vanished by the First World War, the whole point of Dhanjal's Public Art is that it seeks to start where architecture leaves off; that it *uses* elements of architecture and landscape architecture in a search for a new synthesis which might be defined as a kind of secular and vernacular sacredness.[60]

By far the most interesting, albeit limited comment on the sculptor comes from Jacques Rangasamy who rightly stresses the mythic dimension of the work and what he calls the sculptor's 'shamanistic involvement in the lives and spiritual awareness of others'.[61] None of these commentators seem to realize the crucial importance of the idea of Public Art upon the sculptor, an importance which was crystallized when he co-organized a sculptural symposium in the Punjab in 1980.[62] And only Rangasamy seems alerted to the importance of various dualities in the sculptor himself and in the work after that date. The impact of the symposium experience was seminal in terms of his observation of major sculptural figures like Karl Prantle (both in terms of their approaches and their working practices), in terms of his own thinking about his heritage and how it could or should relate to his work, and in terms of the rapid development of his first major site-specific public sculpture.[63] Previous sculpture was divorced from the realities of life but now he was breaking away from the idea of 'the single transportable and saleable commodity', breaking away from the self-referential conventions of modernist art, and was instead seeking to address what Malcolm Miles describes as the 'dynamics of lived experience'.[64] Dhanjal himself remarked that

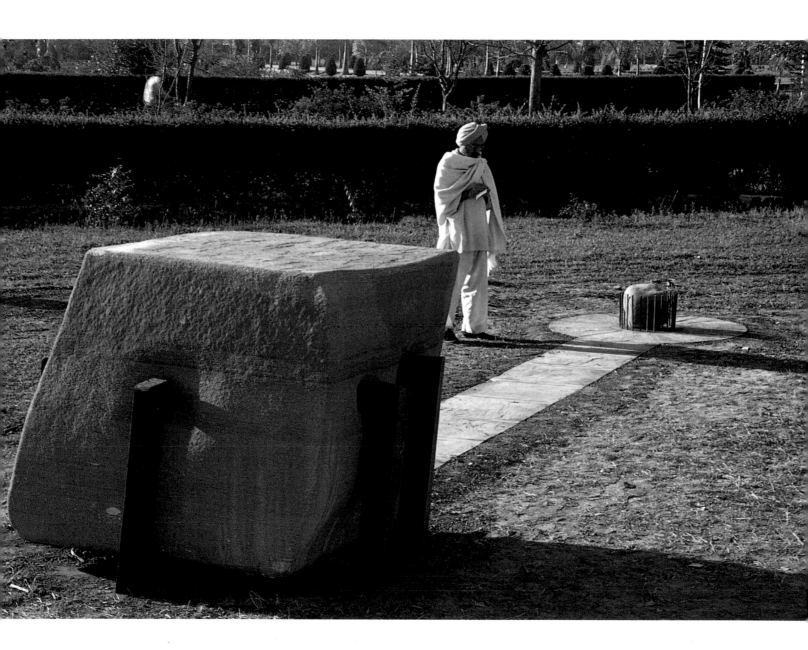

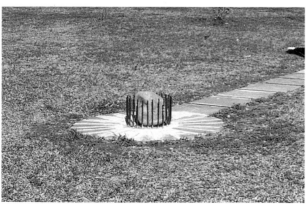

above. Avtarjeet Dhanjal, *The Grip, Technology* or *Technology and Nature*. 1980. Stone and steel. Installation view at, and collection of, Punjabi University, Patiala, India

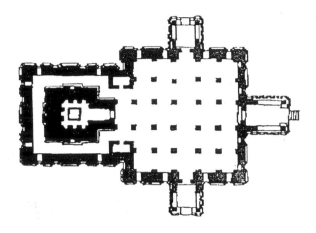
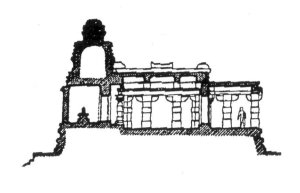

when he visited European sculpture parks, he always asked himself one question: 'how a particular sculpture relates to its surroundings—whether the sculptor knew when he was making the sculpture where it would finally be installed. Many good pieces of sculpture sit still like Siberian birds in their sculpture parks. I have always tried to let my sculpture grow out of the environment, having its roots in that particular piece of land where it stands'. The symposium proved to be the first time that he had located sculpture in a landscape as opposed to merely installing it.

The sculpture he produced was variously called *The Grip, Technology* or *Technology and Nature*. It demonstrated, and to a certain extent resolved, the paradox of technological advancement destroying the old in its pursuit of the novel. Three steel claws grip powerfully (as if trying to contain or eliminate) a large, roughly square, block of sandstone representing the old values of nature. We then progress along a short paved pathway which opens out into a circle, in the centre of which is a time-worn, rounded piece of stone safeguarded by a ring of steel rods as if the technology were now protecting traditional values.

On one level Dhanjal was transforming the Caroesque ground-hugging tradition that he had encountered at St Martin's into a new dimension. He had produced the first of what was to be a series of sculptures (both small and large-scale) in which metal would come out of or imprison stone, culminating in

his site-specific piece for Margam in 1983. This dualism, which may be regarded as that of the traditional versus the modern, technology versus nature or India versus Europe became embedded in the work through the artist's transformation of the ground plan of the traditional Indian temple.[65] A template had been laid.

The basic structure of a temple, if one thinks of it in terms of a ground plan, is that of a square sanctuary (the *Shikara* - many of which have a high curvilinear pyramid on top - which often contains a phallic cylinder of stone called the *lingam* which is the symbol of the creative energy of Shiva). This leads onto a long, rectangular hall called the *mandapa* which in turn leads to an open porch with four square pillars. The symbolism of the temple resides in the fact that it represents, in schematic form, a plan of the universe, or a diagram of the cosmos (the invisible one inhabited by deities, spirits, etc.). Its origin can be traced to the *stupa*, originally a *tumulus*, which was a round, domed brick or stone-built structure that became a hallmark of Buddhism and a potent symbol. It could contain the relics of teachers, saints and even objects used by Buddha. The progression of Dhanjal's public art works can be traced in terms of his conscious or unconscious use of the temple ground-plan, starting with the basic structure of sanctuary, hall and porch as demonstrated by the sculpture at Punjabi University in Patiali, working various permutations upon this structure, and finally simplifying it by going back to the temple origins in the *stupa*.[66]

above. Temple drawings. right and overleaf. Avtarjeet Dhanjal, *Contribution*. 1981. Anodised aluminium and stone. Bodicote House, Banbury, Oxfordshire. Commissioned by Cherwell District Council.

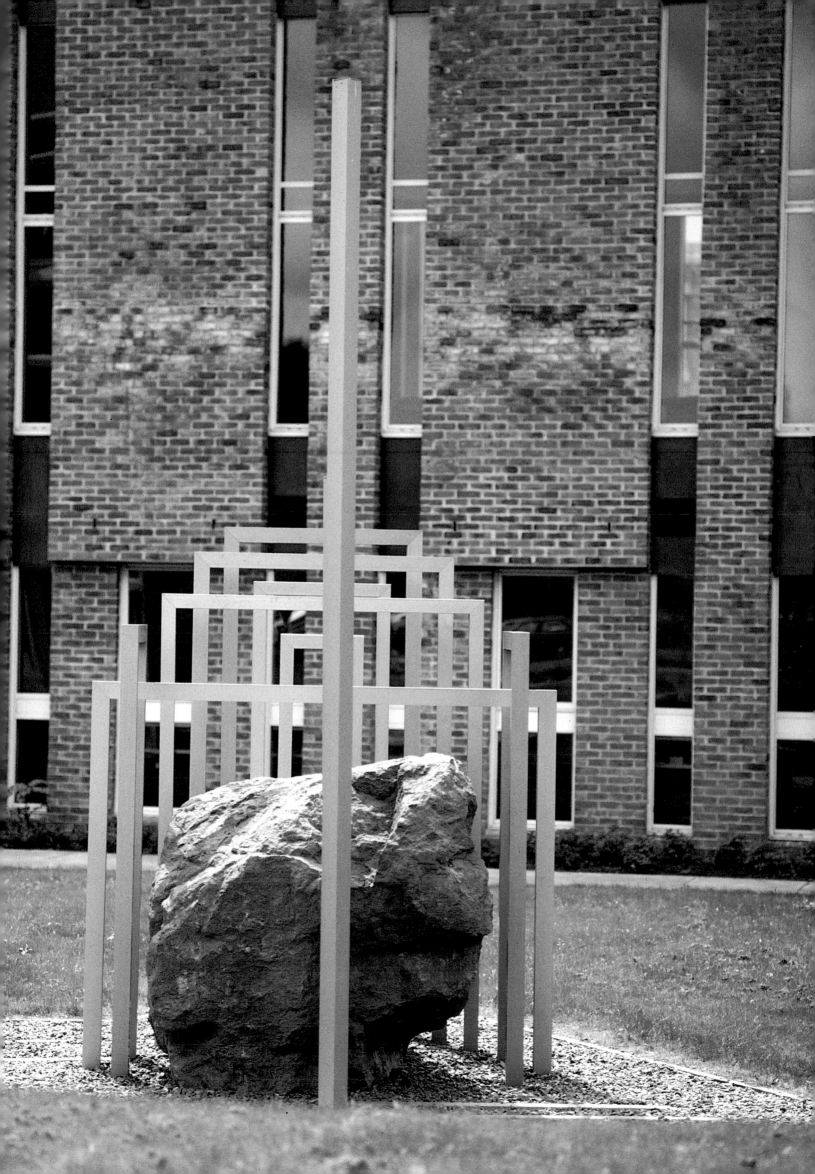

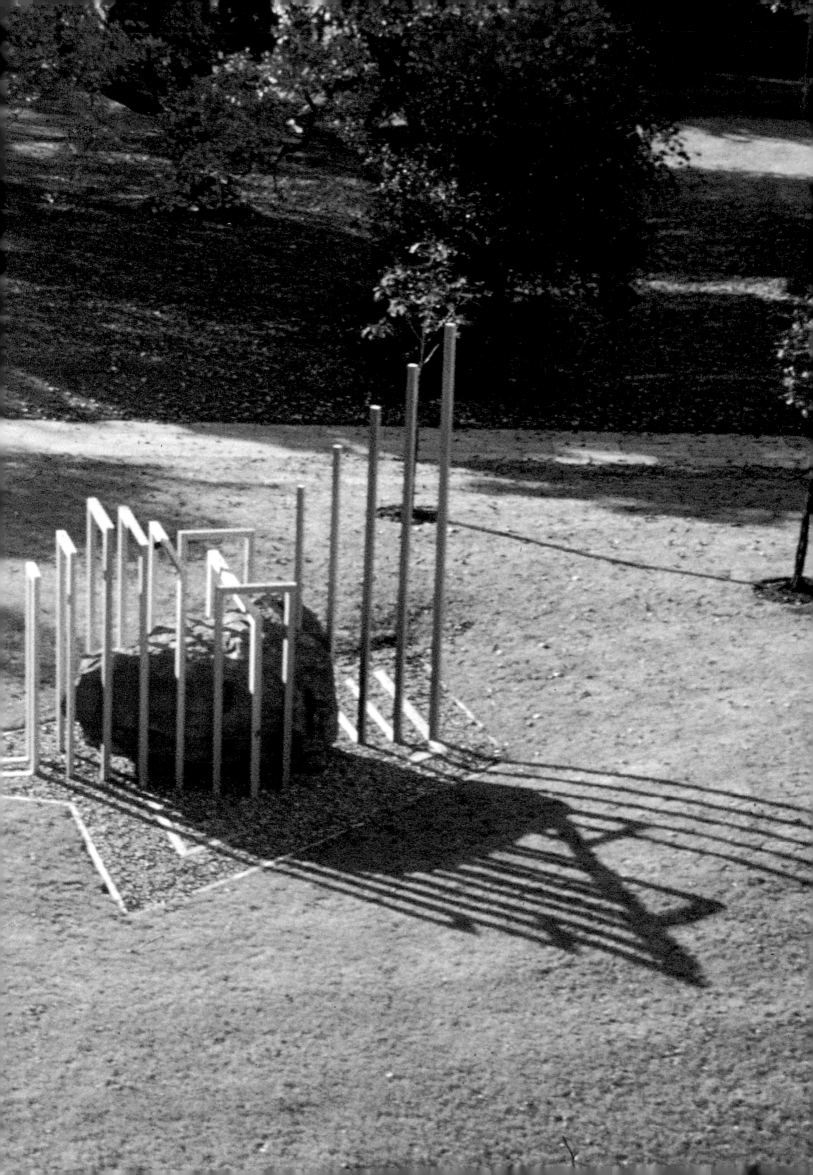

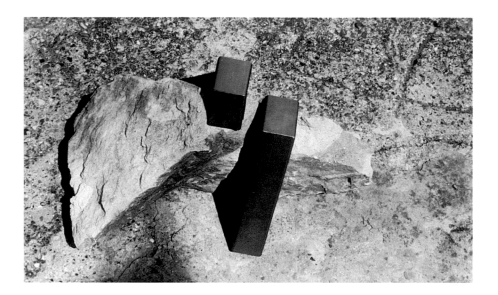

As Charles Correa has pointed out, an Indian architect [and, we can add, an Indian sculptor like Dhanjal] 'creates public as well as private spaces that symbolise and incarnate the non-manifest which we glimpse through religion, philosophy and the arts'.[67] These are generated by mythic beliefs 'expressing the presence of a reality more profound than the manifest world around us. In India these beliefs are all-pervading', such as the sacred gesture (a pattern of coloured powder on a doorway called a *rangoli*) or a *yantra* (a geometric depiction of cosmic order, painted on wall, shrine or temple).[68] While the British initiated substantial changes in the public realm in terms of administration, law and the like, the private and the sacred remained almost undisturbed. One might view Dhanjal's work as his attempt to introduce the private and the sacred into the public realm, initially staking out this dualism in stark narrative fashion. Indeed, one could see this work as the beginning of the idea of art as ecologically healing.[69] Elements emerged that were to remain common to much of his work: the dramatic stage-set; the invitation to a processional approach in the pathway between two areas; the symbolic or metaphorical use of materials; the relationship between looking from the outside in, and being in the middle of the work. This last would be accentuated physically when he began to introduce one or more seats into the fabric of the work.[70]

In 1981, there would be a flurry of gallery activity with an exhibition in Germany and two in Spain, but the major achievement was at Banbury, with a site-specific sculpture aptly called *Contribution*.[71] Before and after the Banbury piece Dhanjal produced a series of small-scale sculptures in which rough uncarved and uncut stone was either encased in an open-ended aluminium cage, or else the aluminium bars would thrust into/out of the stone in a buttress-like fashion suggesting a rather more ambivalent response.

This tension between nature and technology was the focus of *Contribution*.[72] Anxious to bring together materials that were manufactured or found locally, he finally used an 8' x 5' naturally-shaped Hornton stone 'which symbolises the traditional heritage of the area', marrying it to locally extruded aluminium sections from Alcan, 'the product of modern technology'.[73] To do so he linked the unhewn stone to the sawn stone by means of the aluminium sections: 'I wanted this piece to be part of the landscape. You never find a tree out of place because it grows its own roots, creates its own landscape. The aluminium rods on the ground are like the tree's root system, though highly abstracted. The two long roots run down to link to the seat [the cut stone]'. Once again the ground plan is, in essence, that of a temple, though this time, the meditative aspect is brought in more strongly by the transformation of the square 'porch' into what is effectively a seat, encouraging the viewer to sit, observe and be engaged. Paradoxically, the root system, and the 'cage' with its vertical shafts (not unlike a paradigm of a tree from root to branch) is man-made, being of aluminium. The natural element of the uncut rock is

above. Avtarjeet Dhanjal, *Stone and Aluminium Series*. c.1981-2. Kentish Rag stone.

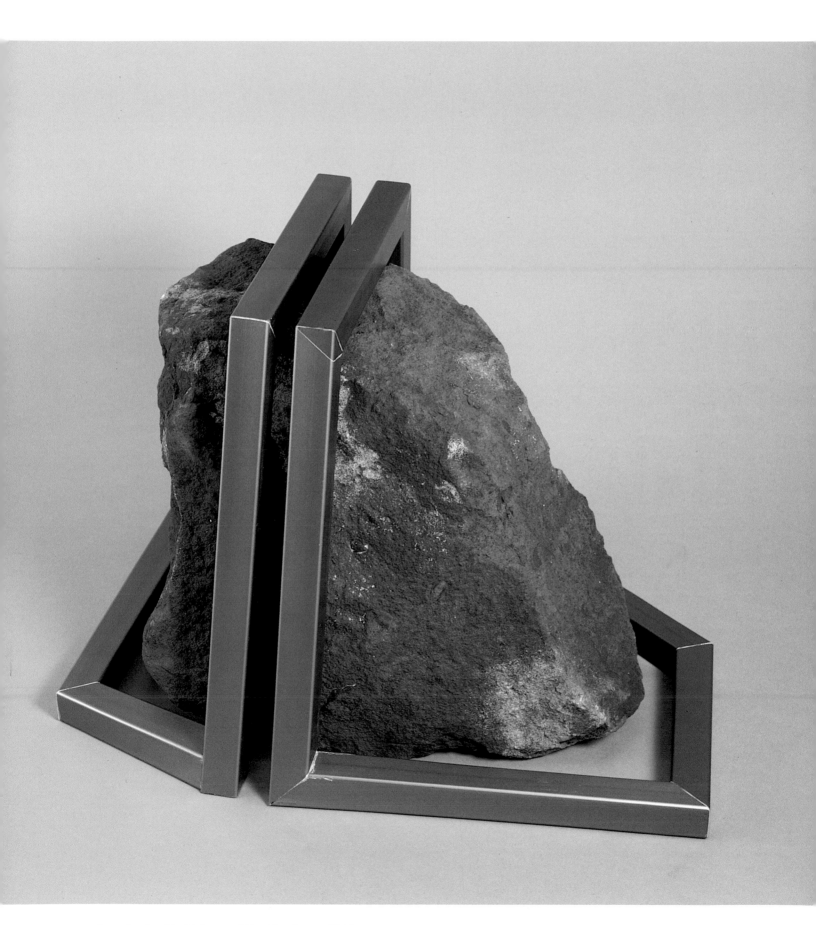

above. Avtarjeet Dhanjal, *Stone and Aluminium Series*. c.1981-2.
Horton Red stone. Photo: Jerry Hardman-Jones.

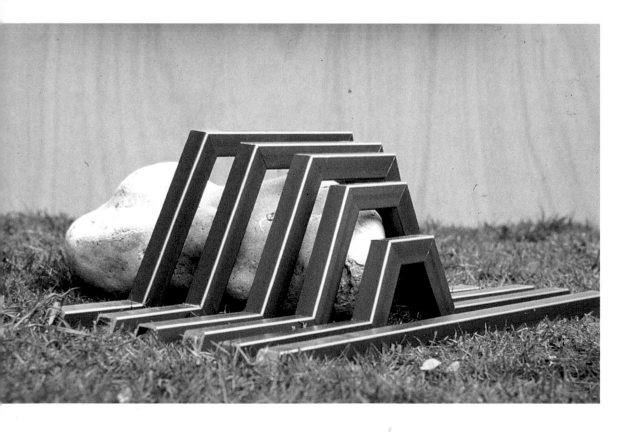

above. Avtarjeet Dhanjal, *Stone and Aluminium Series*. c.1981-2.
right. Avtarjeet Dhanjal, *Wood and Aluminium Series*. c.1982-3.
Photo: Jerry Hardman-Jones.

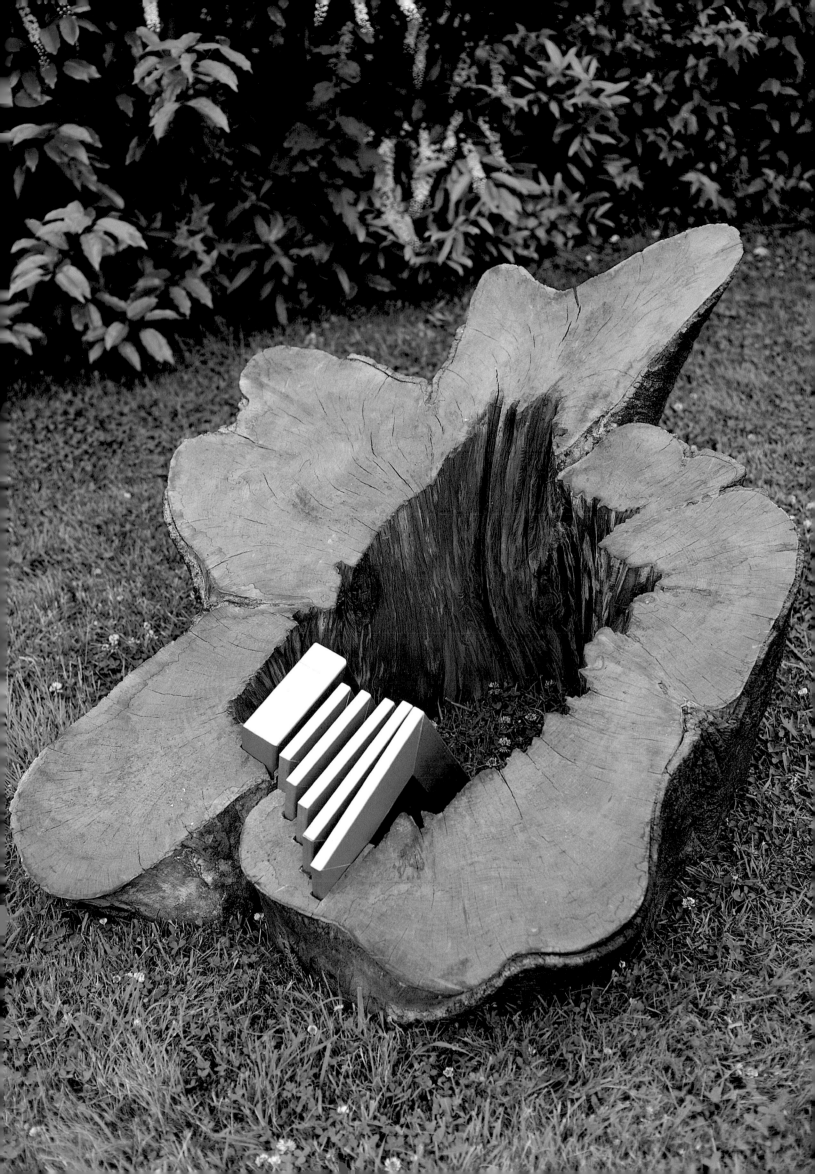

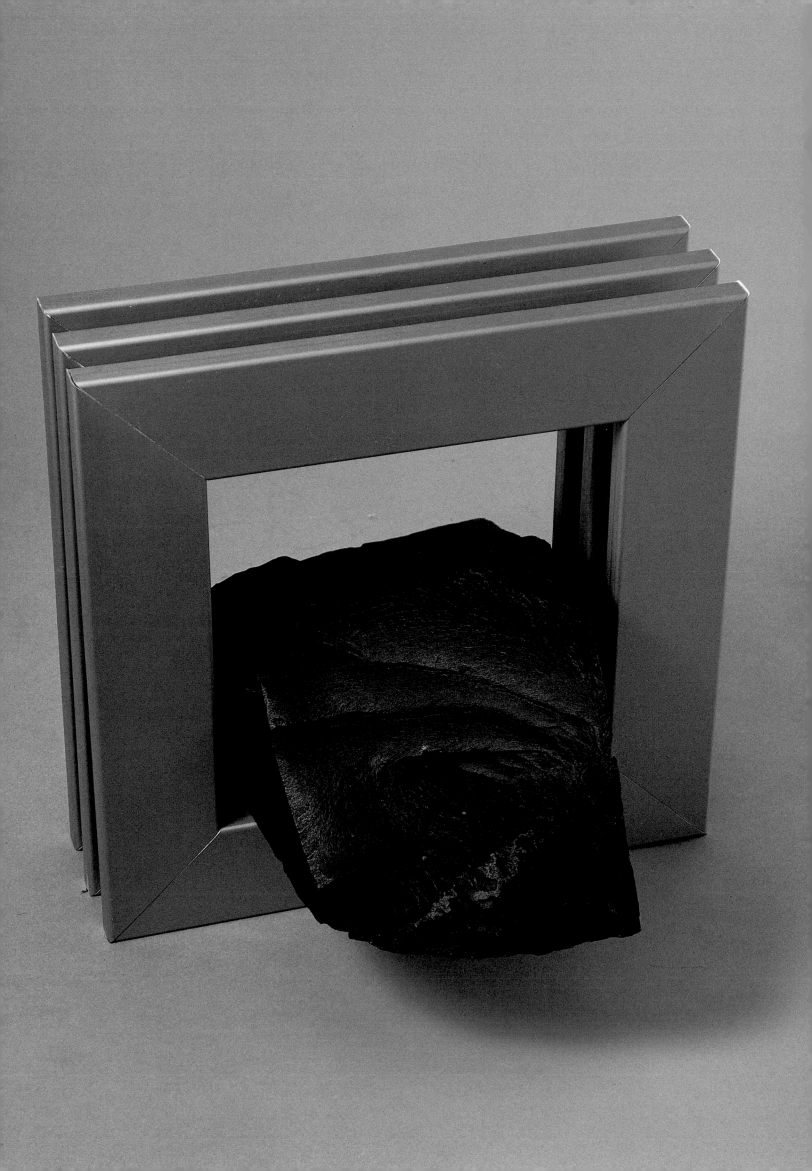

entirely caged and can be viewed in various ways: the aluminium could be trying to grow its 'roots' into the stone; or the stone could be imprisoned within the aluminium cage.

The following year again saw a flurry of exhibitions but the highlight was the sculptor's site-specific contribution to the 'Forma Viva' symposium in Yugoslavia [now Slovenia].[74] 'I didn't plan what I wanted to do. That would be arrogant. What's the point of having an agenda before going to a strange country? You aren't opening yourself to new experiences'.

For the first few days he looked around. On one particular day he was sitting near a road when he noticed a group of children from the village, who came walking past. It triggered memories of himself as a child walking from his village to the High School in the next village. En route was a wayside well, where he would drink on a hot summer's day. It was also a communal focal point for women in the village and a meeting place. 'I thought: these kids don't have that well. They need a place to sit'. So he made a piece in the shape of a water-well with steps around it for people to sit on and a path connecting it to another area where there were five more seats. 'The centre piece, in the shape of a well, involved joining twenty-four pieces of oak with wooden dowels and metal U hooks. I sited this sculpture near the entrance to the monastery [the sculpture park is a twelfth-century monastery converted into a museum] under rows of roadside trees'.[75]

Closer to landscape architecture than to his more serious works, the work still operates on the temple plan, and has a touch of humour in the provision of a well which isn't a well. It modulates with perfect harmony in relation to the natural landscape, and continues the notion of sculpture as being a *place* within which one can sit and meditate: a secular shrine.[76]

An organised visit to the beach during which twenty sculptors worked in sand for a day provided another focus for the artist in that he produced his first installation. He observed that most of the other sculptors were wetting the sand, thus treating it as if it were clay. 'I don't agree with this. One material is not a substitute for another. You respect it'. The result was a series of five pyramids which had a journey imprinted upon them: child's footprints which modulated into those of an adult. The artist used this structure later on in the year at Galerie Werkoff in Germany where the already familiar dialogue between nature and technology re-emerged as the footsteps vanished to be replaced with aluminium strips which lined and 'scaffolded' the pyramidal structures. It would emerge yet again the following year.

left. Avtarjeet Dhanjal, *Stone and Aluminium Series.* c.1981-2.
Photo: Jerry Hardman-Jones.
above. Avtarjeet Dhanjal at *Wayside Well.* 1982.

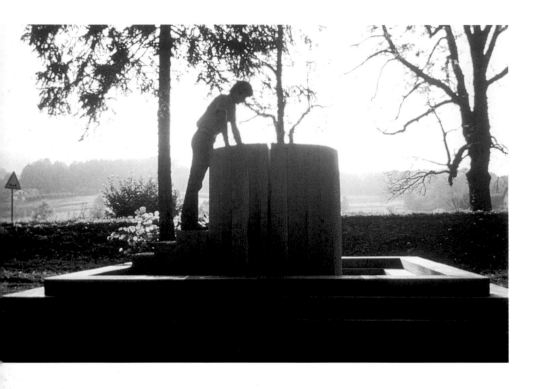

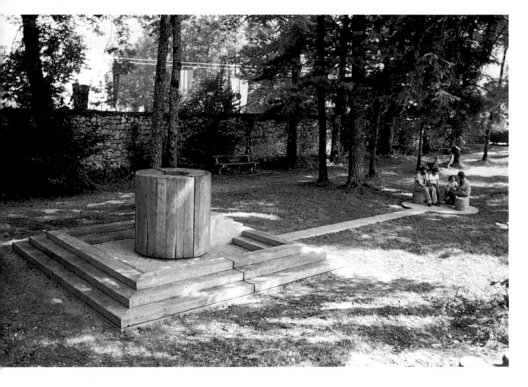

above and right. Avtarjeet Dhanjal, *Wayside Well*. 1982. Oakwood and concrete. Installation views at 'Forma Viva' International Symposium of Sculpture, Kostanjevica, Former Yugoslavia.

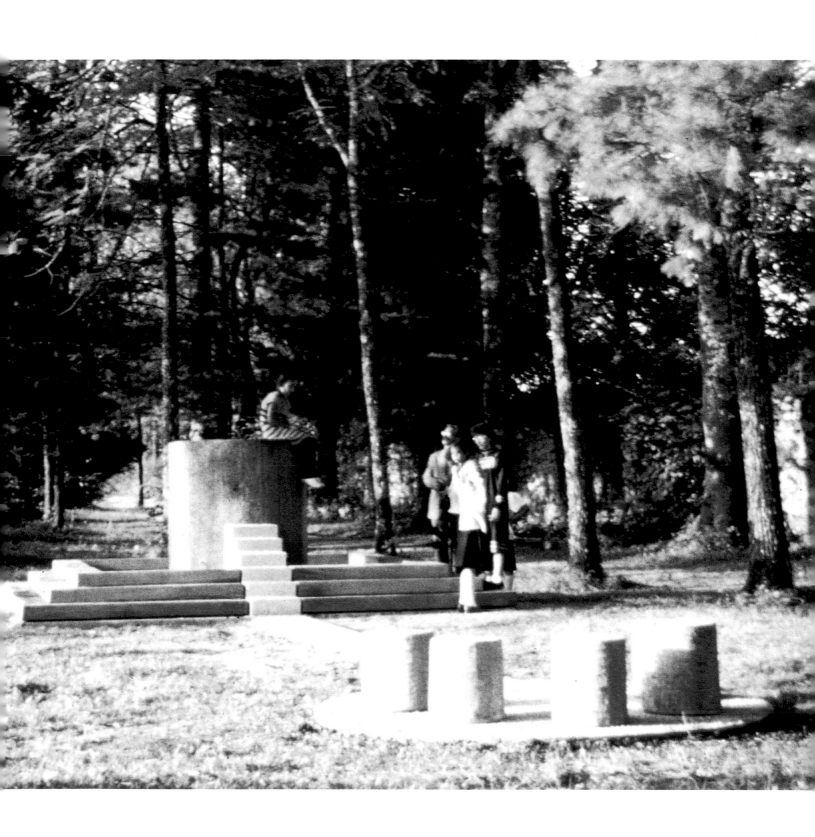

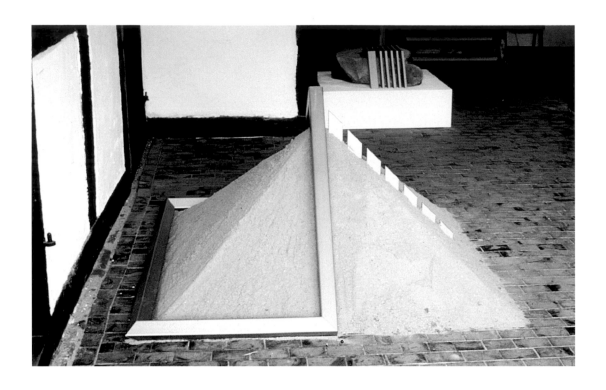

above. Avtarjeet Dhanjal, *Sand and Aluminium Series*. 1982. Installation
view at Galerie Werkhoff, Bissendorf, Germany.

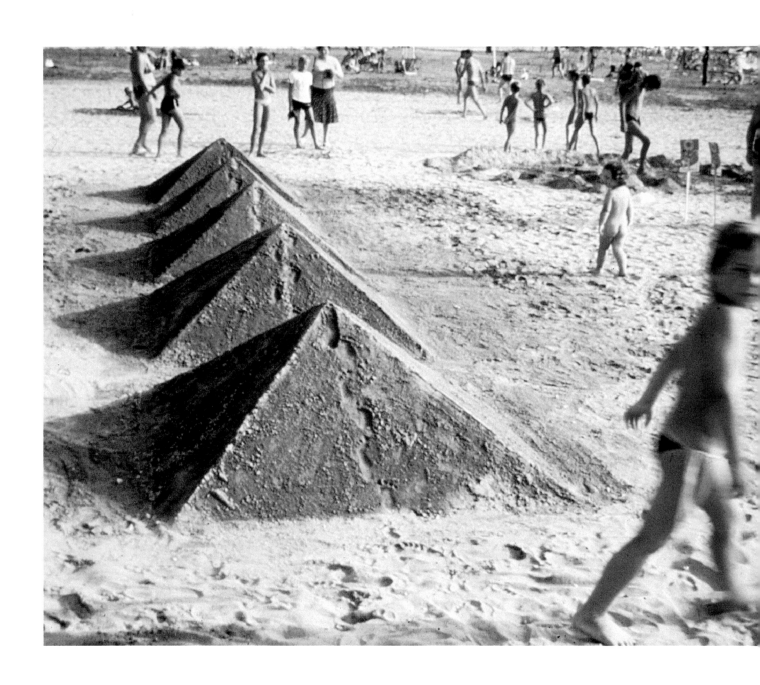

above. Avtarjeet Dhanjal, *Across Five Pyramids*. 1982. Sand and powder
colour. Installation view at Portoroz Summer Festival, Portoroz Beach,
Former Yugoslavia.

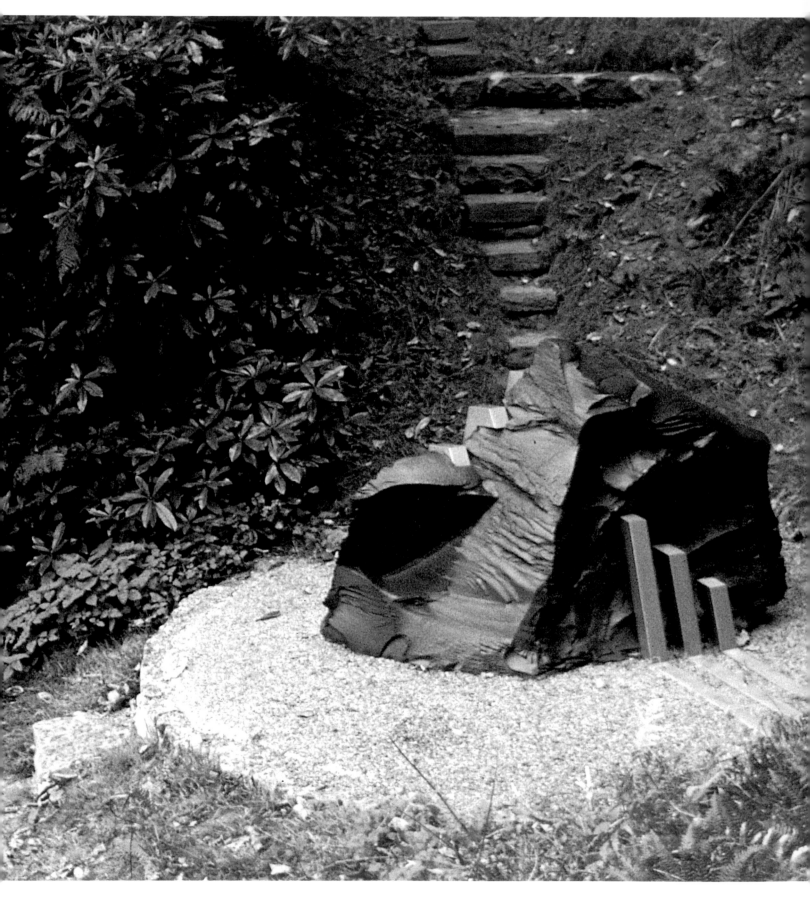

above. Avtarjeet Dhanjal, *83 Steps*. 1983. Installation view at Margam
Sculpture Park, Wales.

Phase Two: Slate and Fire

A period of exploration and experiment followed in 1983 which saw the artist's first use of slate and fire as materials. In the sculpture park at Margam in Wales he had an opportunity as an invited artist to produce another site-specific work. Situated in a thousand acres of parkland with lakes, formal gardens, and hills, Dhanjal found himself sheltering in a thicket during the rain. Perhaps with Forma Viva being fresh in his mind, he decided to make two seats for it: wayside seats one might call them. The whole piece grew from there. Called *83 Steps*, it is a literal journey during which, in Rangsamy's prescient phrase 'walking becomes a metaphor for the heart beating'. The trail, which starts at a seat under a bamboo bush, leads one up a small hill, through trees and into a circular space dug out of the hillside. There a seat allows one to observe a slate rock, buttressed by the now familiar aluminium strips as well as a view into the outside world which then contained one of Britain's largest steel plants. Stretching back to the Punjab symposium, we can observe the duality of tradition and technology, the processional format, the placing of the spectator within the work and, in elongated form, the outline plan of the temple. This time the reminiscence is of Indian cave temples, often cut into a hillside, and as in an Indian temple, the seat is elevated, allowing you to view downwards.

In June 1983 Dhanjal was appointed to a three-month residency with North Eastern Gas (NEGAS – part of the British Gas Board) at their training-college in Leeds, as part of the Artist-in-Industry project promoted by the Yorkshire Arts Association. As an article in the company newsletter indicates the average industrial worker had a long way to go in his understanding of modern art: 'They're getting used to some pretty strange goings on down at the New Wortley Training College'.[77]

The Public Relations Department which was handling the residency assumed that the hardware of the large gas installations would stimulate the artist but on the contrary he found himself interested in gas as a material. 'I was amazed to find out, when a high pressure gas is injected into a low pressure supply line, the temperature of the gas drops so much that a gas burner is used to heat up the frozen pipe'.[78] After receiving lessons in safety and copper plumbing techniques, he learnt about the combustion system of gas, and designed and made his own burners. As he wanted to 'draw lines of flame on the sand's surface and wanted to see the interaction between flame and solid materials like stone', his first sculpture at NEGAS *Flame Line Pyramid* emerged as a sand pyramid with a flame ribbon running from bottom to top on one side.[79] This was swiftly followed by candle-like flames emerging from a piece of alabaster in a piece called *Ten Candles*. As the Public Relations Department were keen on having an outdoor sculpture for the training college, he planned a row of twelve-inch high gas torches emerging from a six-ton rock which then continued on into the ground.

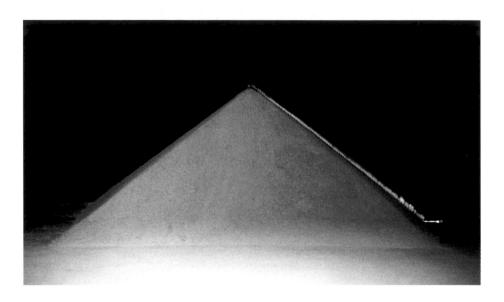

At one point it seems that his ambitions stretched to linking the gas plant, a roundabout and a nearby hill into a huge flame-active installation: a kind of landscape walking-in-fire. However lack of support as well as technical difficulties forced him to use yellow polyethylene studs as a substitute for the flames, and to eschew the environmental exploration. The final sculpture was entitled *36 Torches*, currently sited in the grounds of New Wortley Training College. It has a companion piece called *48 Torches* which was sited in the children's park of the then new town of Telford. Seeing the latter *in situ*, one is prompted to regret that Dhanjal never continued with his more experimental forays. The yellow studs entirely change the metaphors of the piece, transforming it from a kinetic and sacral act into a pleasant piece of outdoor sculpture, looking not unlike an archaeological skeleton of a dinosaur.[80]

Dhanjal seems to have been unsatisfied by the end of the residency. Over the next two years he worked on a series of slate pieces which grew out of the Margam experience. Much of 1984 was spent building a family home in Chandigarh, an experience which clearly fed into the slate sculptures, reinforced his sense of Indian culture, and doubtless focused the debate between modernism as represented by Chandigarh city and tradition as represented by the Punjabi villages. It would also have exacerbated his sense of being stranded between two cultures. The Prime Minister Indira Gandhi was assassinated in that year, a year which had also seen the traumatic events of the storming of the Sikh holy shrines in the Golden

Temple complex in Amritsar, Punjab.[81] England, of course, was in the midst of the Thatcher years, and had her own occasionally traumatic events in the shape of the IRA.

By March 1985 he was in Saint Louis as an invited guest of the Arts Festival where he made two installations, the second of which was in the nature of a performance event.[82] The first, which was situated in Maryland Plaza, was symbolically called *Peacemaker*. It consisted of a huge metal drum, acquired from the city scrapyard and painted grey and red so that it 'looks hot', from which radiated tree-trunk size logs.[83] A photograph of the piece indicates the presence of at least one rock. Volland, obviously following the artist's viewpoint, considers it as a wedding of the natural and the manmade 'to point up the need of modern man to balance nature and technology for human survival'.[84] Dhanjal himself remarked that it was a comment on the paradox of Reagan's 'Kill everyone: it's a peaceful world' viewpoint but it is just as likely to be a reflection on the previous year's events in the Punjab.

The second installation, which was a development from the candles used in his slate sculptures, comprised a series of fifteen specially-cast giant candles which were floated in a connected semi-circle and lit at 7.30 p.m. in the middle of the Grand Basin in Forest Park. The candles, fifteen inches in diameter, were made by pouring wax into plastic drums, and used hessian rope as wicks. Local television stations covered the event and Dhanjal

above. Avtarjeet Dhanjal, *Flame Line Pyramid*. 1983. Sand and gas flame. NEGAS Residency, Leeds.

right. Avtarjeet Dhanjal, *36 Torches*. 1983. York stone and polyethylene. Installation view at NEGAS New Wortley Training College, Leeds.

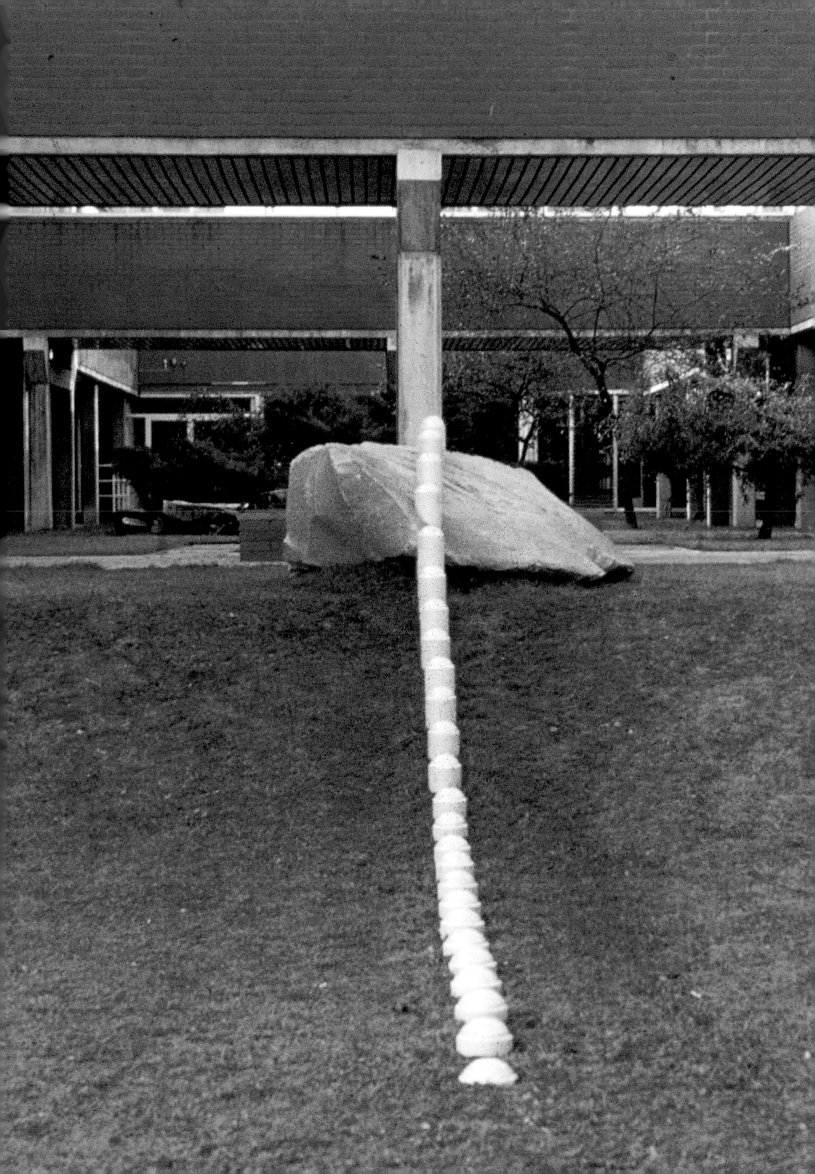

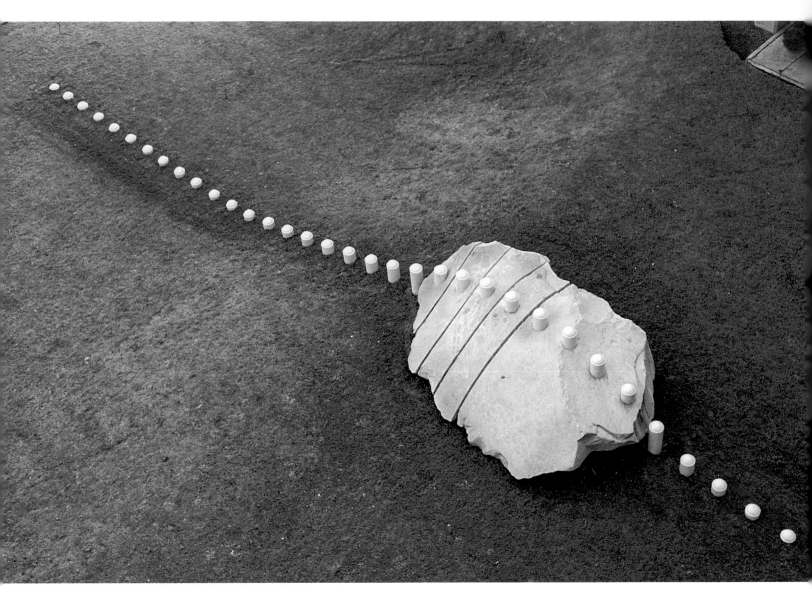

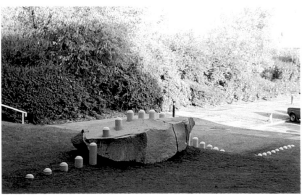

above top. Avtarjeet Dhanjal, *48 Torches*. 1983. York stone and polyethylene. Installation view at Weston Park, Sheffield (now sited at Children's Park, Telford).

below. Avtarjeet Dhanjal, *36 Torches*. 1983. York stone and polyethylene. Aerial view at NEGAS New Wortley Training College, Leeds.

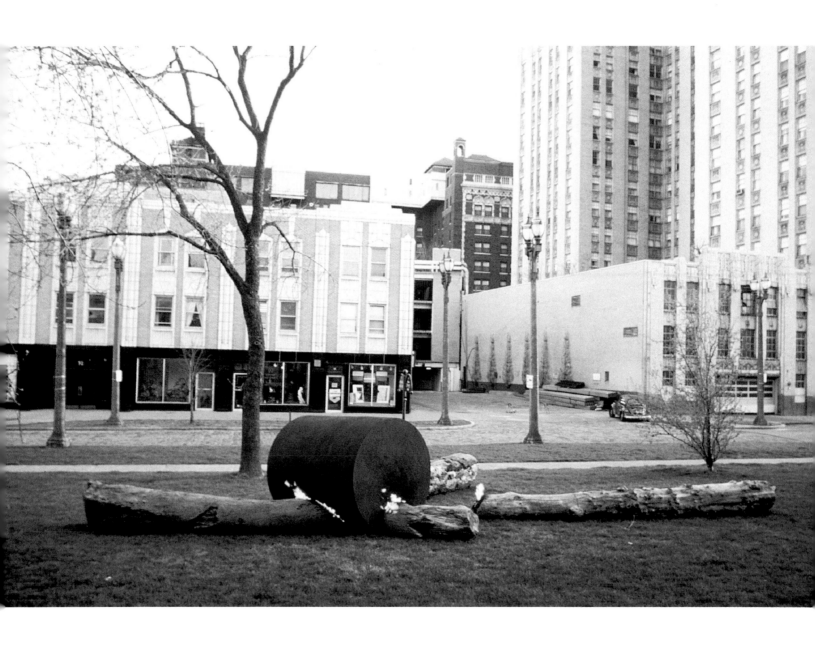

above. Avtarjeet Dhanjal, *Peacemaker*. 1985. Metal drum, fire and logs. 59
Installation view at Maryland Plaza, St. Louis, USA.

above and right. Avtarjeet Dhanjal, *Along the Trail*. 1986. Welsh slate and rope. Installation views at, and commissioned by, the National Garden Festival, Stoke-on-Trent.

regarded it as a 'magical experience'. He was now ready to create a major work, optimistically dedicated to World Peace, which would emerge within the environs of Peace Green, Wolverhampton in 1986.

But before that, in an echo of his work at Margam, he created the temporary outdoor sculpture *Along the Trail* for the National Garden Festival in Stoke-on-Trent. Like Margam this piece was processional, its long pathway being composed of Welsh slate. It was a journey with an occasional event happening on the way. A two-ton rock, for example, made a seat, the back part of which according to the artist 'had a hole drilled through its nose and [was] tied with a rope to a wooden peg. It looked as if this was to stop the rock from walking away'. Although there were clear formal and environmental similarities with the Margam work, both of which fulfilled the artist's dictum of 'growing out of the soil like trees', and both of which engaged in walking as a metaphor for the beating of the heart, *Along the Trail* had more in common with the *Wayside Well* for Forma Viva. It had the same humour, and the same relaxed relationship to its surroundings. While, in the Forma Viva work, the focal point was the well, at Stoke, the seat became an end in itself. Like the *Wayside Well*, it could have been used for resting and contemplation but the temple ground plan had vanished—or to be more precise we were only given a partial ground plan with the result that the sacral aspect failed to put in an appearance.

Phase Three: Return to the Temple 1986–1992

Francis Street Green, now known as Peace Green is roughly a mile from the centre of Wolverhampton. It is surrounded on all four sides by terraced housing. Dhanjal had a three-month residency in the nearby Valley Park Secondary School, enabling him to work towards a commission for 'a work of art' for the Green. He also became a member of the council's landscape team and as Bill Lonsdale has remarked: 'By suggesting that the site offered an opportunity to create a synthesis between sculpture and landscape, art and design, he challenged the narrow concept of sculpture which we held', thus effectively removing the notion of a sculpture on a pedestal.[85] Dhanjal, of course, was only too aware that the area had a large Muslim population, none of whom were interested in 'men-on-horses' as figurative art is forbidden under Islamic law.

The main structure consists of a colonnaded entrance, planted with creepers (no longer there), entered through a series of semi-circular steps and funnelling into an archway which in turn leads into a circular space surrounded by seats cut into York stone. This space also contains a tall 'window' and a semi-circular wall which echoes the semi-circular mound in the distance.[86] The seats have a 'sly' playful humour.[87] One is flat-bottomed, another is for 'a little prince', another for a 'happy couple' actually consists of two big-bottomed seats joined together; another is for a mother and child (small and large), another has a missing armrest for a lopsided person and so on.

Dhanjal worked on them with local people, giving them names such as Seat for a Fallen King, Spinster's Seat, and The Happy Couple. This local co-operation was evident elsewhere. Close to the edge of the park is a v-shaped wall, arrowing into the park, and composed of red bricks. The bricks were obtained in their unbaked state from Baggeridge Colliery, given to the pupils in the school where the sculptor had his residency, and they were asked to work on one side of the brick only, before they were fired. The result is a delightful range of nicknames, symbols and designs which even includes the Sikh separatist slogan (in Punjabi) 'Sikhs will rule the world' as well as an outline of a gun.[88] Dhanjal also did a workshop with local youths, using left-over stone, by means of which he created a parallel circular area in a copse across the way.

Dunstall Henge, so-named by a local historian, is a remarkable work. The title aptly suggests its ability to plug into the prehistoric archaeological landscape of Britain, a landscape typified by Stonehenge and Avebury Stone Circle. Created as a space in which to play music, hold meetings or say prayers, it is both a place for doing things in, as well as a site for contemplation. In its original form with its canopy of foliage, the work was allowed to bleed naturally into the landscape. Because of its remarkable harmony of siting, it still does.

The structure itself returns to the ground-plan of the temple though in a more complicated form. The colonnade suggests echoes of the columned temple

preceeding page and above. Avtarjeet Dhanjal, *Fifteen Floating Flames*. 1985. Cast wax, wicks and fire. Performance installation at Grand Basin Lake, Forest Park, St. Louis, USA.

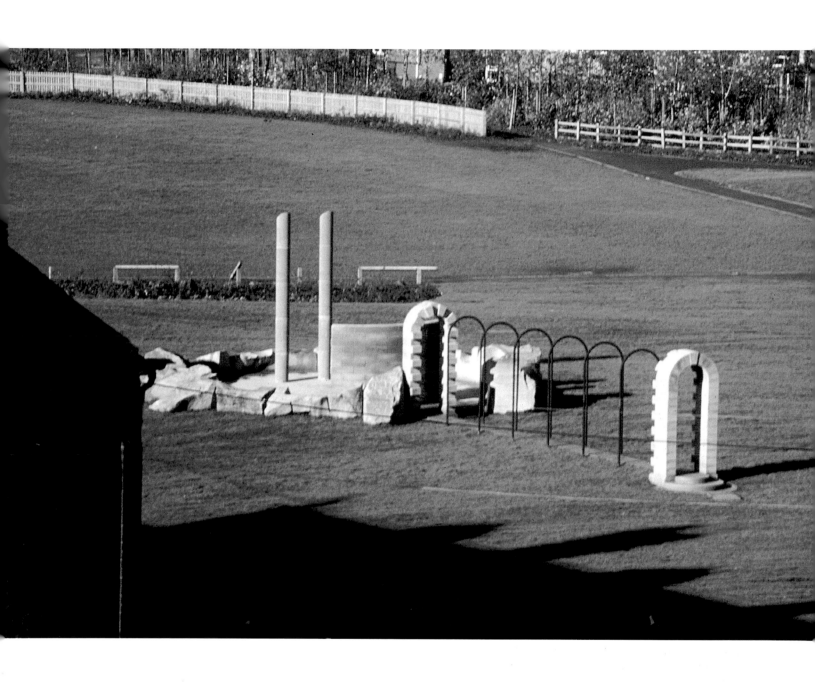

above. Avtarjeet Dhanjal, *Dunstall Henge*. 1986. York stone, steel and
creepers. Installation view at Peace Green, Wolverhampton.

above. Avtarjeet Dhanjal, detail of *Dunstall Henge*. 1986.

right. Avtarjeet Dhanjal, *Dunstall Henge*. 1986. York stone, steel and creepers. Installation view at Peace Green, Wolverhampton.

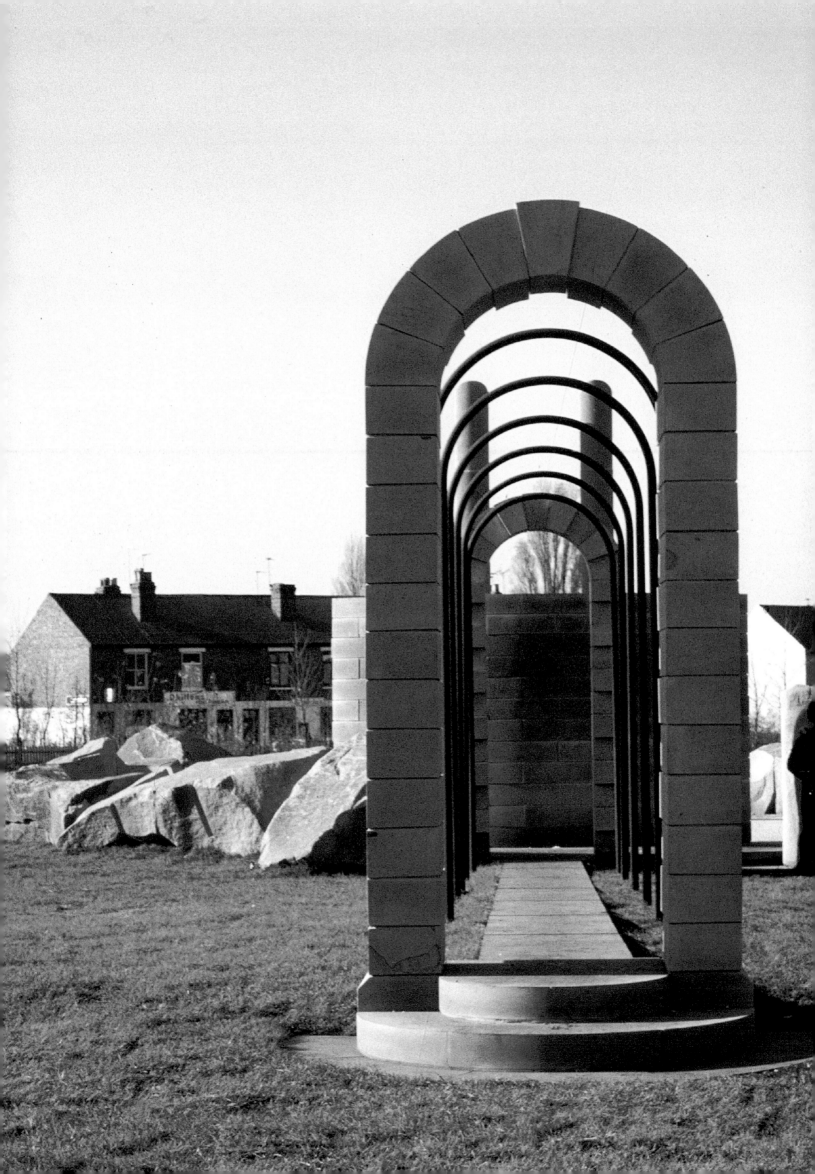

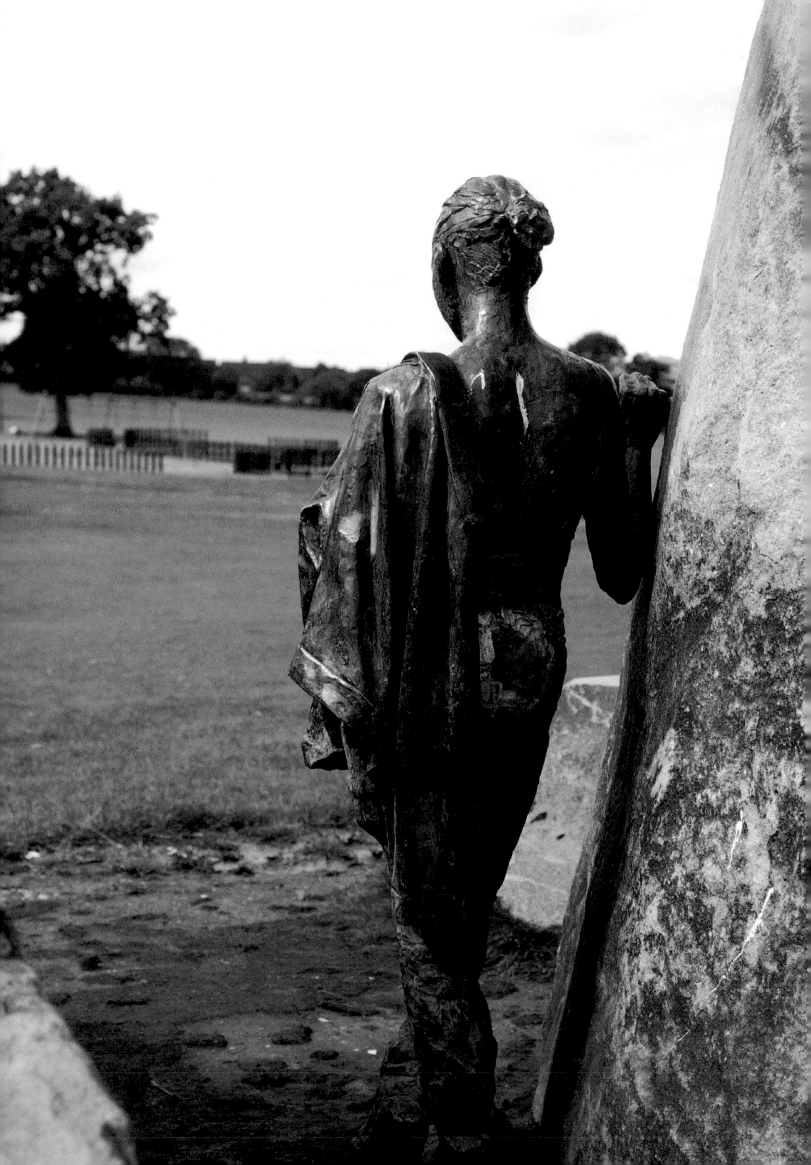

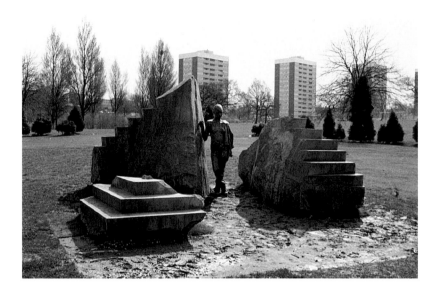

caves, while the tall 'window' is reminiscent of the outline shape of, say, the sanctuary in the Papanath temple.

Compared to the interventions at Margam or Stoke, this is more compact, more resonant, and more fully integrated into the mythic as well as the natural landscape. It is also more fully cognizant of the needs of the surrounding local communities. It commingles East and West in a subtle union of religion and myth. Compared to the turgid monstrosities that pass muster as Public Art in the squares and parks of much of Middle England (Birmingham being a prime example) this is a model of engaged art-practice and is as site-specific and site-sensitive as they come.[89]

Working on *Dunstall Henge* had a happy side-effect. While travelling around he came across a location in Shropshire, and within a year he had moved from London and was building a house and studio at Ironbridge, at long last reintroducing himself to the *via media* of town and country. The next few years were presumably occupied in this fashion although he did have a sculptural show in London at the Horizon Gallery, and another school residency at Hillcrest School, Birmingham, before plunging into another commission, this time for Senneley's Park in Birmingham—as well as participating in *The Other Story* at the Hayward Gallery.

Called *Eroded Pyramid,* the Senneley's Park intervention is a strange and baffling work because it seems to go against many of the artist's principles.
 Senneley's Park is in an area which has a predominantly Muslim population. Whereas his natural tact had ensured that the Muslim population of Wolverhampton would not have to view a figurative image, this work actually incorporated a full-length modelled figure of a girl, of the kind he used to create in Chandigarh, only this time cast in bronze. The basic idea of the piece was that in times long past, a stepped pyramid existed upon which a girl used to play. Many years later she returns, only to find that the pyramid has been heavily eroded. If one imagines viewing such a pyramid from the air, erosion has reduced it to three substantial remnants (stones of roughly eleven, eight and one and a half tons), so aligned that the remaining steps cut into these remnants would, if extrapolated, meet at the apex of the original pyramid. The life-size cast of the erect girl, one leg casually crossed over the other and her jacket hanging casually from her shoulder, was situated between the two largest remnants, her eyes downcast amidst these remains of her civilization.

So instead of work which incorporates the traditions and beliefs of the local community and involves them, this one seems to be entirely in the domain of the private. Although the artist has said that the siting was not his original one (he wanted to site it in the natural hollow of a wide open adjacent field), its present placement is carelessly chosen. The slender path that rises gently up to the work restricts viewing, and its overtly urban backdrop fails to mesh. It was a conceptual idea which needed the immensities of a rolling rural field rather than the suburban niceties of a manicured section of parkland.
Yet the basic idea has considerable mileage. It

left. Avtarjeet Dhanjal, *Eroded Pyramid.* 1989. Stone and bronze. Installation view (detail) at Senneley's Park, Birmingham.

above. Avtarjeet Dhanjal, *Eroded Pyramid.* 1989. Stone and bronze. Installation view at Senneley's Park, Birmingham.

contains two versions of the theme of loss, that of the erosion of the self, as age will wither the outward vessel of the body as surely as the erosion of the pyramid; and that of the erosion of the man–made landscape — man's monuments to himself and to his gods. Loss, ageing and entropy are intriguing ideas, as is the tension created between the figurative and the abstracted. It was a bold step to reincorporate a modelled life-size figurative image into his work. On one level it may have been an attempt to synthesise a nagging interest in the figurative with that strand of his work which first appeared in the pyramidal structures on the beach at Forma Viva. Like *Dunstall Henge* it may have been part of his attempt to simplify his work in outline plan and compact it: the pyramidal structure of a *Shikara* doing duty as a compressed temple. In common with that work it suggests a kind of archaeological detritus, plugging us into an ancient culture, and thus suggesting its continuity and change. However, in its current somewhat unkempt state, the idea only partially resonates. The figure has long since been stolen, and the siting, while adequate from one viewpoint, makes it difficult to realize that the three blocks were meant to be the remnants of a larger one. Essentially this is a sculpture placed rather than located in a landscape. And yet, even when a Dhanjal work fails to live up to expectations, this work, like his other public art sculptures and like the slate pieces that would be exhibited for the first time in *The Other Story*, does draw upon a whole range of empathies, traditions, ideas and dreams. The emphasis on figuration and human agency, for the first time in Dhanjal's work since his days at Chandigarh seems at odds with the references to natural forces which suggest the Eastern metaphysics of 'our lives are but a grain of sand'. In a sense *Eroded Pyramid* with its life-size figure, makes explicit rather than implicit reference to that dualism and is, perhaps, unsuccessful for that reason.

In 1990, enlarging upon the earlier event in St. Louis, Dhanjal lit 5000 tiny floating candles on the surface of a small lake. He had gone to São Paulo to deliver a series of lectures on art. 'Fifteen or twenty people came to my talks. They suggested that we do an event. So we bought candles, made tee-shirts printed with my poems, and one of them played the flute. It came together. I was struck by the homelessness of children in the streets, so the 5000 candles were 5000 candles for justice'.

The following year he travelled in South India to study temple sculpture on a travel award from West Midland Arts, sent some of the stone and aluminium sculptures for inclusion in *Il Sud del Mondo (the South of the World exhibition)* in Sicily, and also participated in a Japanese show.[90] While he was in India he realised a commission from the City Administrator of Chandigarh.[91] A circular marble-stoned area with a conical marble section in the middle, was, initially, surrounded by trees or shrubs with only one entry, theoretically hedged on both sides, leading to it from the far distance. Outside the circle of shrubs is a series of boulders with seats carved in them, all facing outwards, except for a double seat, meant for lovers, at one end. 'Once you enter in, you actually turn away from worldly tensions and get surrounded by the serenity of nature. You turn to your inner peace to stabilise yourself. The stones with carved seats were to allow breathing space to the people occupying them'.[92] However the sculpture has been severely neglected. Most of the trees are dead, there is no tiled approach-way, and only one hedge.

This work, deliberately created for the modernist city of Chandigarh and sited in a green space close to the museum and the art college, is a bridge between Dhanjal's ideas as articulated in *Dunstall Henge*, and the work which he would develop at Maltings. As in *Dunstall Henge* there is a circular pattern of carved seats, treated with a distinct touch of humour, though the sacral aspect is modulated here into a simplification of the temple idea, returning to its origins in the *stupa*—a theme which would be continued and deepened at Maltings. The dualism of tradition and modernity is forcefully exploited: the modernity of the city juxtaposed with what Le Corbusier left out, the Indian tradition as evidenced by the *stupa* reference. It is almost as if the sculptor were saying: ignore the hurly-burly of a modern city with its emphasis on getting things done within a specific time frame, and return to the Indian tradition of quiet, serene contemplation; a tradition in which time elongates, and allows you to breathe.

right. Avtarjeet Dhanjal, *Maltings Park Project*. 1992. Installation view. Commissioned by Cardiff Bay Development Corporation.

Phase Four: Integration and Essence 1992 to the present day

In the following year, 1992, Dhanjal started work on Maltings Park, Cardiff, situated on the site of the former East Moors steelworks. Robert Camlin has described the genesis of the project. Dhanjal was initially one of the design team and his work fell into three phases: 1) being part of the team, asking questions such as 'Why do people come into the park?', and 'What part does it play in their lives?'; 2) interpreting the mood of the place, through the symbols of the I Ching (the Book of Changes), into a visual language; and 3) punctuating this with individual pieces where needed.[94]

Camlin comments that pedestrian routes through the park ensure that it is seen as part of the city. Care has been taken to make a clear demarcation between public and private realms, with respect for the park's neighbours and the need to encourage visitors being influential factors. In composition 'the park is like a family dwelling in which each member enjoys an outdoor "room"...while there are opportunities for all the family to gather for special events such as barbecues'.[95] He quotes Dhanjal on the site, remarking that it is 'more than just a piece of land. It tells you a story of centuries of man's use and abuse and has a subterranean life of its own'. Then he argues that their idea is for the ghosts of previous cultures to take new form 'in the substance of the park — as beacons to mark entrances, a grass "crucible" to recall the alchemy of steel-making, and

long avenues [to indicate] where goods wagons once clattered'.[96]

At Maltings Park, Dhanjal returns to an old theme, the relationship between tradition and technological change, only in this case the technology has vanished and become the history. It is change itself, and the need to understand it, that is really the subject of the piece. Dhanjal's intention was to carve sixty-four small limestone pillars (though only fifteen have been carved so far), each one with symbols abstracted from I Ching, and then visually reinterpreted by the sculptor.[97] As Camlin points out, stones have always been used as markers for routes, boundaries and sacred places. Dhanjal considered them as 'a way of mapping the place and marking what the feelings were that I got from these places'. These markers emphasise the underlying grid pattern of the park (the diameter of the crucible being used as a 'measure' for the grid).

The markers often have a sly wit. While many of them create a pictorial language of tree and fire, of male and female forces, a number of them, inspired by Indian temple sculpture's unabashed use of the erotic, are positively jokey. One block of twenty-five markers (should they ever be completed) will have a variety of different heights, creating a kind of inverted pyramid which appears as yet another allusion to temple architecture.

One of the sculptor's punctuation marks is a large flattish slab of sandstone, positioned in the crucible

above. Avtarjeet Dhanjal, *Female Form and Tree*. Carving on stone marker. Detail of Maltings Park project commissioned by Cardiff Bay Development Corporation. Photo: John Donat, courtesy Quadrant Public Relations.

right. Avtarjeet Dhanjal, *Woman and Children*. Carving on stone marker. Detail of Maltings Park project commissioned by Cardiff Bay Development Corporation. Photo: John Donat. Courtesy Quadrant Public Relations.

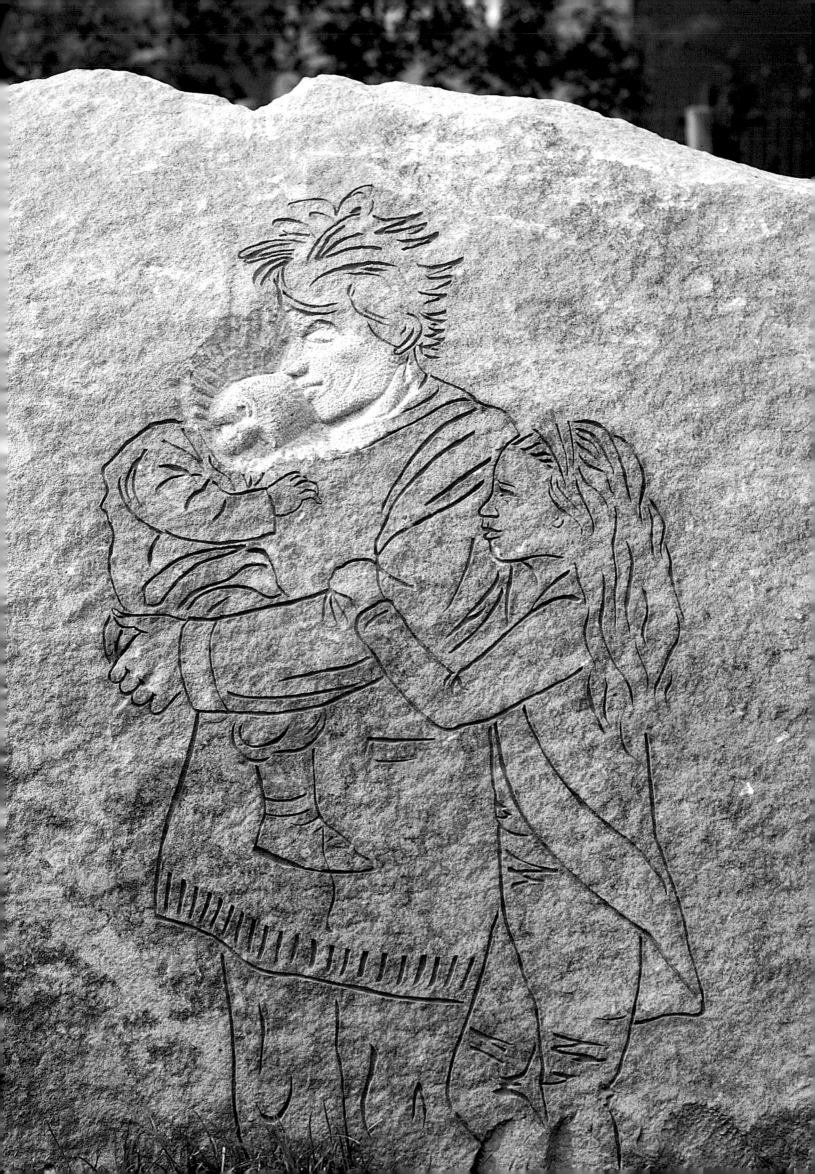

area, upon one face of which he sandblasted the outline of a mother and child, and then carved the head of the child. Dhanjal had previously photographed the local community, held an exhibition of the photographs, and based the sandblasted image on two of those caught by his camera. On the other side of the rock he carved a loose translation of a Mexican poem which reads: I walk/on this beautiful Earth/looking looking/wondering/being amazed/only course left for me/is to go all the way.

Another punctuation mark is 'The Reception' which contains four benches and four trees in the artist's familiar arrangement for rest and meditation. In another area, one goes up a little hill, up steps on one side, meets a wall with a hole in it, causing one to bend down and observe two sunken stones which contain the 'key' or map to the rest. It is a temple without being a temple just as the wayside well was not a well. Like a temple you step through the portal. Elsewhere there are two 'windows', each with inscriptions based on the Mexican idea of four different winds. 'The Morning Breeze', the Eastern window, is invigorating and creates hope; the Southern window is the midday wind, warm and energising, bringing a sense of security; while the two windows as yet unmade are the Western evening wind grinding you down as the day approaches and the Northern wind.

Even in its incomplete state Maltings is a remarkable achievement. Although it would seem that work has come to a standstill and there is little sign of renewal, it is nevertheless an astonishingly fluent translation of Eastern philosophy and Eastern temple architecture into an archetypical Western industrialized city which is in the grip of powerful change.[98] All of the classic Dhanjal concepts are in place: the seating areas for rest and meditation; the processional elements; the invitation to be within the work; the marked sensitivity to place, siting and nature; the conjuring of a time frame, both in terms of immediate history as well as mythic time; and the insistence on utility. Whether the landscape architects were aware of these underlying aspects is open to question. One can only hope that, if the sculptor does not get the opportunity to finish this scheme, then his acceptance of the lead role in the team for the new Farm Park project in Birmingham will allow him to develop a complete and fully integrated project on the scale of Maltings.

The Slate Works

The slate works avoid the overt amalgam of South Asian and Western aesthetics which the West derides as 'derivative' and opt for a kind of visual poetry in which the value lies beyond the physical reality of the piece. They represent a journey, one part of which is the artist's journey to synthesise Western abstraction (or perhaps more properly reinvent Eastern abstraction) to an Eastern spirituality, the other part of which is the journey of the displacement of cultures. What Rasheed Araeen terms 'otherness' is not revealed in 'clear depictions of sub-continent scenes from a remembered homeland' or in the 'use of styles derived from Indian art such as Mughal miniatures or Tantric art'.[99] Rather it is revealed in works which seem to belong to neither East nor West.

Dhanjal first started to work with slate at Margam in 1983, followed by Stoke in 1986, with the independent slate works beginning to emerge in 1984 and 1985. Five of these were shown in *The Other Story*.[100] Another five have been developed since then, one of which was commissioned for Cartwright Hall in Bradford by the Institute of International Visual Arts and Bradford Arts, Museums and Libraries.[101] He started using slate in Margam because 'I always like to use something that belongs to the area. They said slate. I went to the quarry and saw millions of tons of the stuff, mountains of it, on a hillside. In the village where I lived, there was no electricity. Dark nights become pitch black. Darkness becomes solid. We don't see this in England as the big towns reflect light into the sky, even ten miles away. In the village, any light burning becomes magical. So I started using slate as a symbol of darkness, and drilled holes into it for the candles'.

As a child, Dhanjal wrote on slate. In his autobiographical fragments he notes that 'there were few households in the village that would have more than one lamp: the dense darkness was very frightening. Most parts of the house were dark too...the streets were dark except for the few days of a full moon'.[102] On another occasion he refers to sleeping on the roof terrace at home on summer nights 'under the dark blue sky full of stars. ..We watched stars changing positions at different times of the night and different times of the year. We watched and talked about the moon almost every night'.[103]

It is not difficult to see the slate works as a distillation of these memories. Essentially they are blocks of

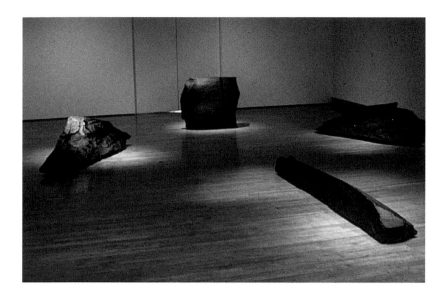

slate, fractured, ridged and weathered, found objects from the quarry-like miniature hillsides which bear the imprint of geological time. Dhanjal makes minimal modifications to these objects. He drills small holes in them into which night lights made out of black wax are fitted, ready to be lit and to illuminate the blocks into flickering life. You could say that they are abstracted constellations in the night sky but they are equally *mandalas*, pictograms or maps of the universe of the gods. The slate acts as an interface between the natural and the industrial, its functionality being transformed into art.

The minimal modifications to the slate extend to other markings: a pictogram of the rays of the sun; and various sequences of tiny steps—tiny steps at the side of huge blocks of slate.[104] In Western thought, a journey has typically been seen as an A-Z, whereas in Eastern terms it is usually thought of as circular. One does not know where it will conclude.[105] As the journey or the search becomes more intense, it funnels or narrows. If one imagines the steps to be larger, their magic and the mystery would be lost. Their very minimalism is the point: a journey or a human life, dwarfed by the immensities of the cosmos. The steps themselves just stop, which is in itself a kind of metaphor. It is akin to Kierkegaard's 'leap of faith' in that one has to trust to faith if one wishes to believe and to survive.

This is not to say that Dhanjal is attempting to illustrate or embody a specific religious faith such as

Sikhism. As I have remarked before, his fusion of East and West seems to have resulted, in his work at least, in what I termed a secular religious essence. As it is, these sculptures appear to be doorways to another reality. They embody the dualism that emerged in so much of his public sculpture but in a more discrete form, referring to the art and the beauty that is inherent in everything that is not man-made, but still holding in suspension the need to make a personal gesture.

Initially slate and fire were the two properties that the sculptor explored. He has remarked that he can only deal with one element at a time in a work. If the secular altars of slate and candlelight were the first phase, the second phase is his exploration of slate and water. Again it is the reflective quality that attracts him. He asked the stonemasons for the technically impossible: having gouged an elliptical, and then a circular 'bowl' out of two large pieces of slate, Dhanjal then asked them to mirror polish the slate-bowl. Traditionally this was regarded as impossible as slate is too soft, but Dhanjal persisted and the masons achieved a result.

In these sculptures, the selected rocks are ridged and weathered so that as the chief stonemason remarked 'we began to see one piece of slate as a riverbed, through [Avtar]Jeet's eyes'.[106] The piece with an elliptical bowl, meant for outdoors, has handles carved on both sides of the bowl, pegs inserted about a foot away on both sides and ropes tied to it.

above. Avtarjeet Dhanjal, *Slate Works*. 1984-87. Installation view at *The Other Story* Exhibition at the Hayward Gallery, London, 1989. Photo: Eddie Chambers.

75

The piece tilts so that water flows out of the bowl, following the weatherings on the slate, as if it were a miniature riverbed itself. The indoor piece, with its circular bowl and a series of four night-lights inserted into drilled holes, allows the reflections of the nightlit stars to flicker in the water-filled bowl.

The artist's journey in search of harmony and an at-oneness with nature has been partially achieved: from childhood, staring up at the night sky in the Punjab, to Ironbridge, symbol of the Industrial revolution; from Chandigarh, quintessence of modernism, where he adopted the superficial transfer of abstract images from another culture, to the England of London, Birmingham, Wolverhampton or Leeds where, through a kind of osmotic pressure, his Indian culture seeped into his site-specific community-based public sculptures, finally fusing with the West in the triumphant *pieces des resistances* of the slate sculptures.

It is important to realise that Dhanjal does not thrive on binary oppositions. East and West, nature and nurture, the colonised and the colonial, history and the present (and many other such seeming oppositions) need to be viewed as *part of an endless process* within which economy of materials and vocabulary are essential. Even the very notions of art and craft, or art and architecture — as witness the house which he built for himself — operate within this stricture, for the artist states firmly that 'for me, the situation and context I'm working in determine the work…I don't really know whether what I do is art or not. People like to have a handle on you. I called myself an artist — until I found out what that was!'

The sting in the tail is typical of the man—and of the artist. There is always a riddling residue. At a time when critics forever talk of resolution, closure and completeness, Dhanjal reasserts what sensible people have always known: that an element of incompleteness, or a deliberate lack of total resolution, will often, like the grit in the oyster, produce a pearl of complexity. Opening up; not closing down. Resonance; not resolution.

right. Avtarjeet Dhanjal, *Open Circle*. 1984-85. Slate and candles. Photo: Jerry Hardman-Jones.

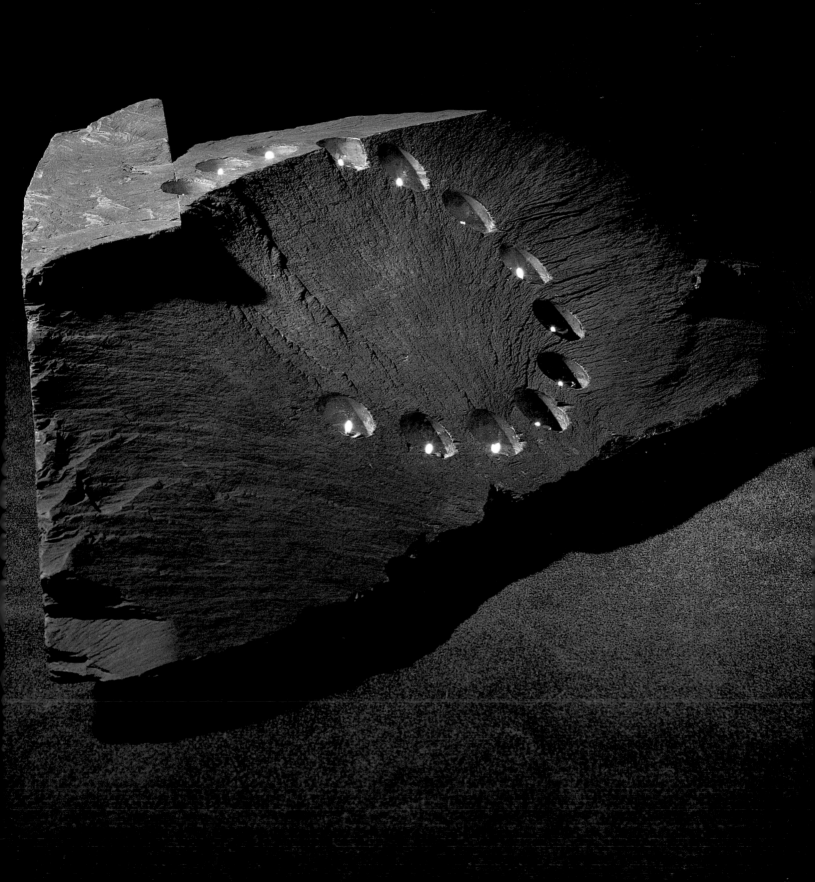

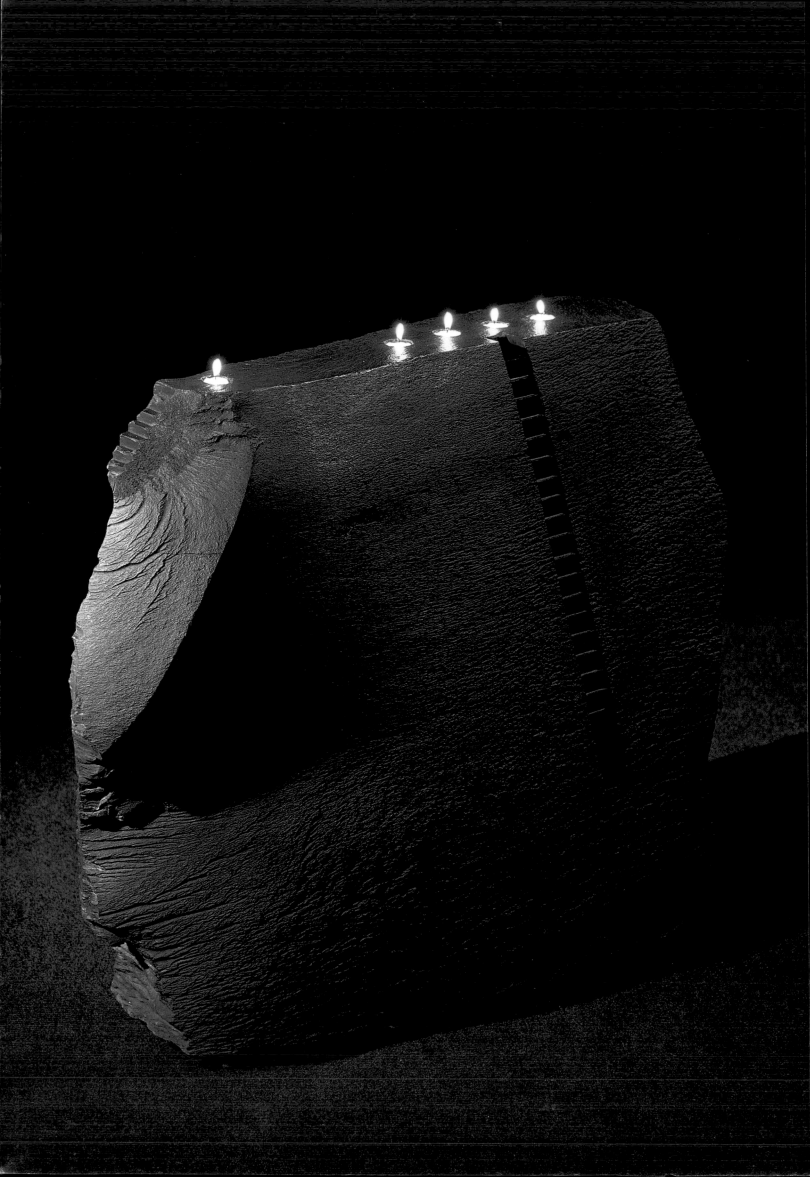

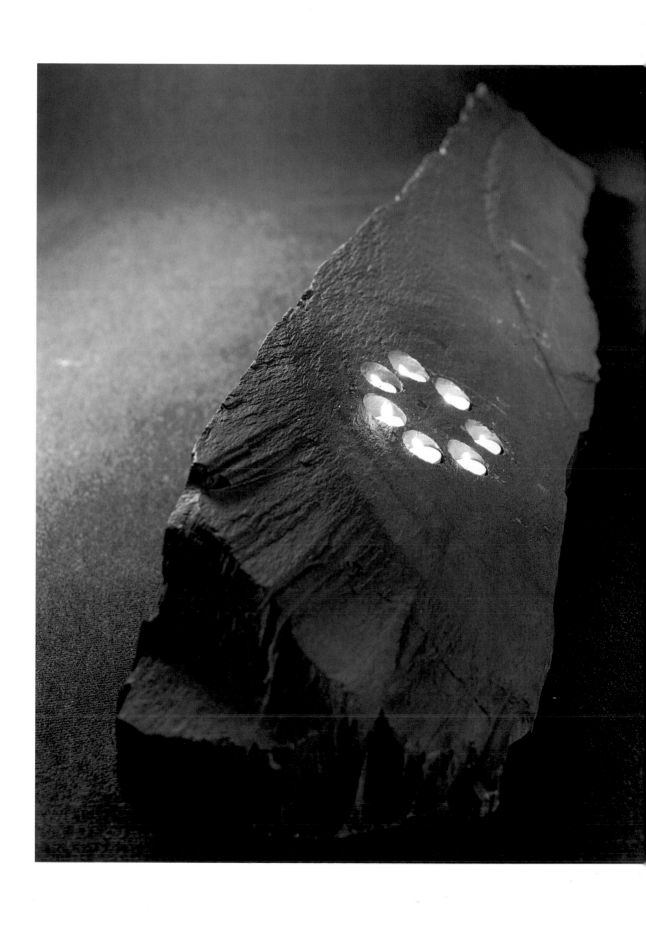

left. Avtarjeet Dhanjal, *Upper Level 1*. 1984-85. Slate and candles.
Photo: Jerry Hardman-Jones.

above. Avtarjeet Dhanjal, *Needle*. 1984-85. Slate and candles.
Photo: Jerry Hardman-Jones.

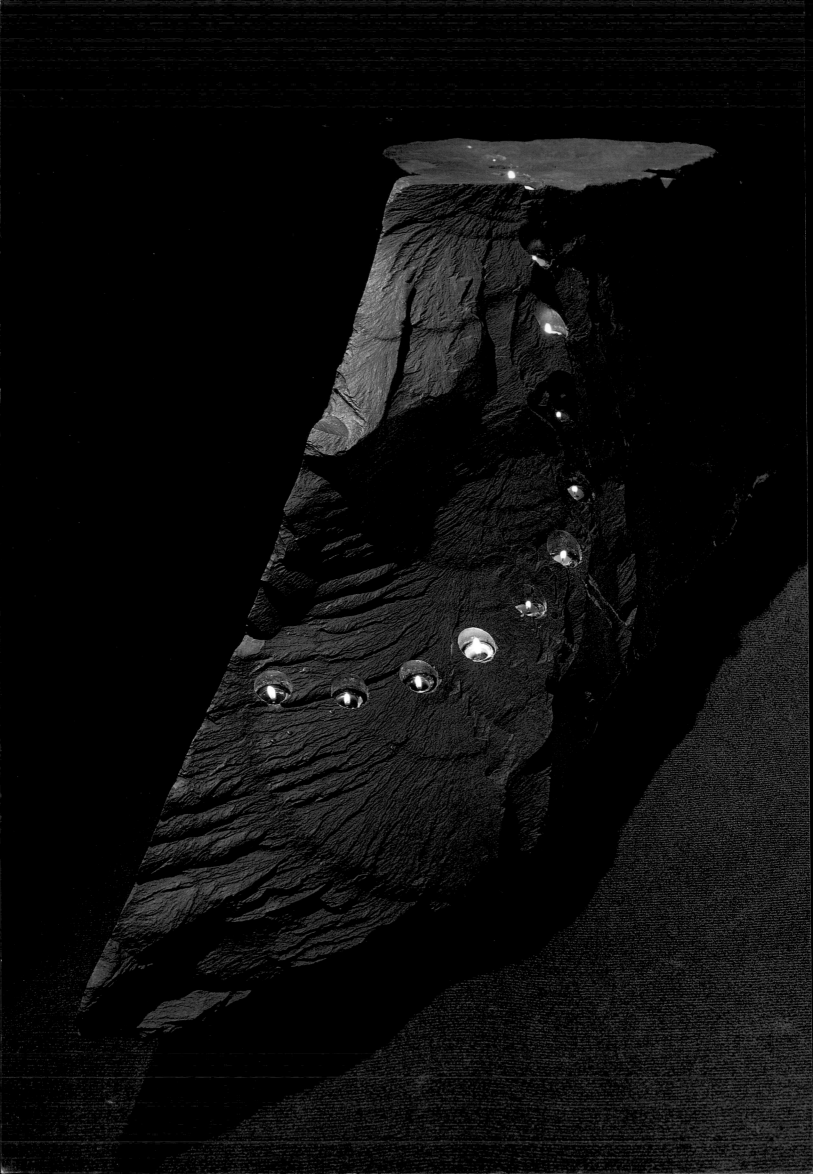

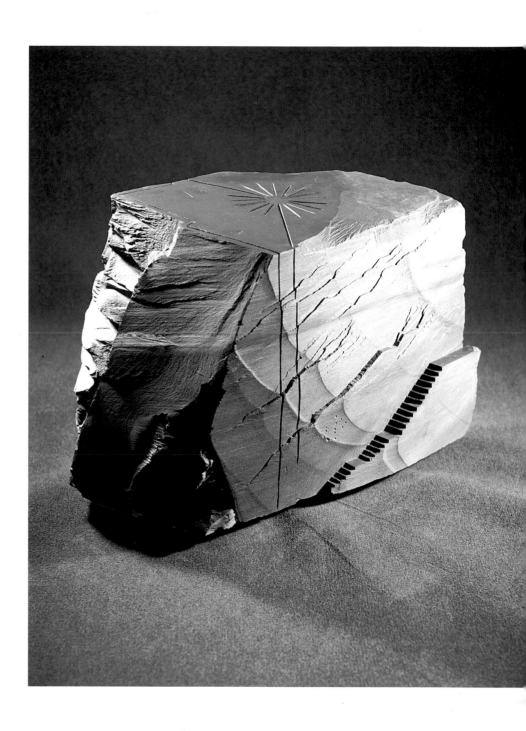

left. Avtarjeet Dhanjal, *Valley of Lights*. 1984-85. Slate and candles.
Photo: Jerry Hardman-Jones.

above. Avtarjeet Dhanjal, *Upper Level 2*. 1987. Slate.
Photo: Jerry Hardman-Jones.

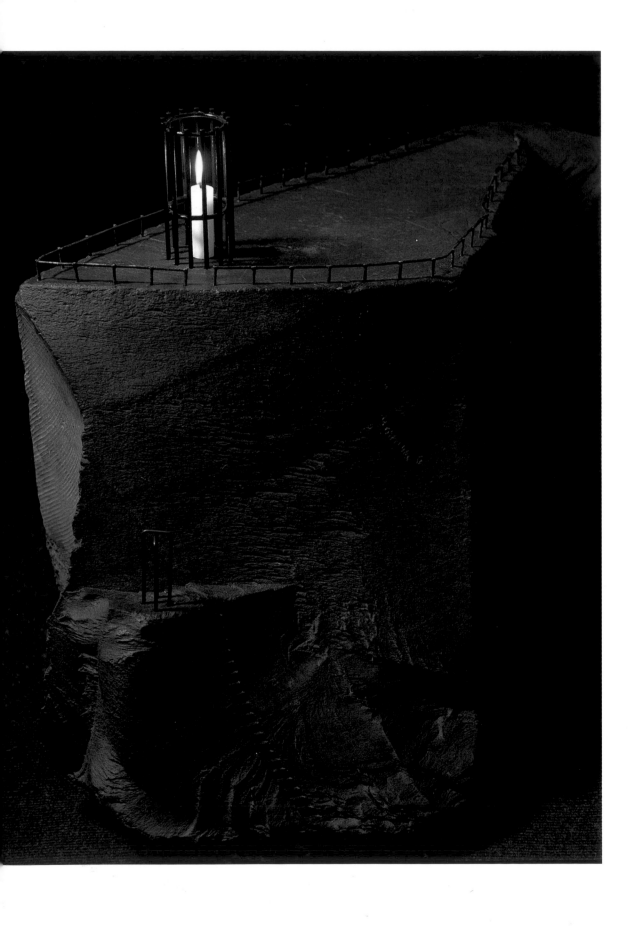

above. Avtarjeet Dhanjal, *The Candle*. c.1984-85. Slate, steel and candle.
Photo: Jerry Hardman-Jones. Commissioned for *Freedom* exhibition by
Amnesty International UK.

right. Avtarjeet Dhanjal, *Slate Series*. 1996-97. Slate, water and rope.
Photo: Jerry Hardman-Jones.

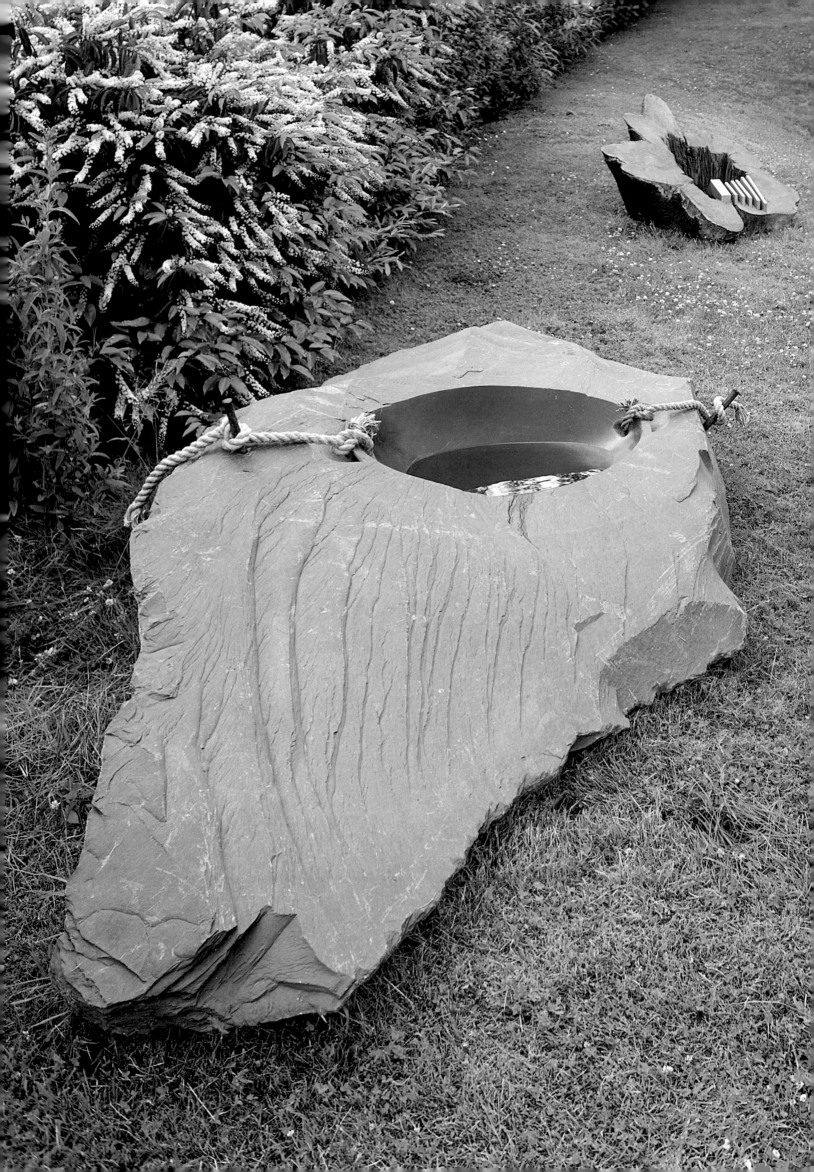

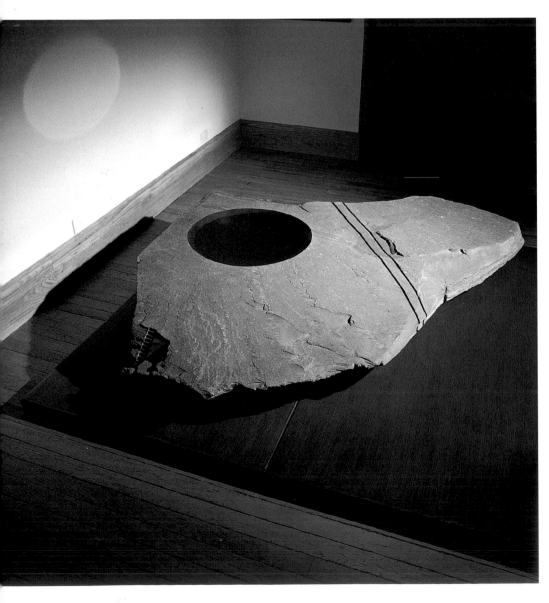

above. Avtarjeet Dhanjal, *Slate Series*. 1996-97. Slate and water.
Collection of Bradford Art Galleries and Museums. Commissioned by
Cartwright Hall and the Institute of International Visual Arts.

right. Avtarjeet Dhanjal, *Untitled*. 1997. Perspex, leaves and UV lights.
(background: light boxes installation). Installation view at Pitshanger
Manor and Gallery, Ealing. Photo: Jerry Hardman-Jones.

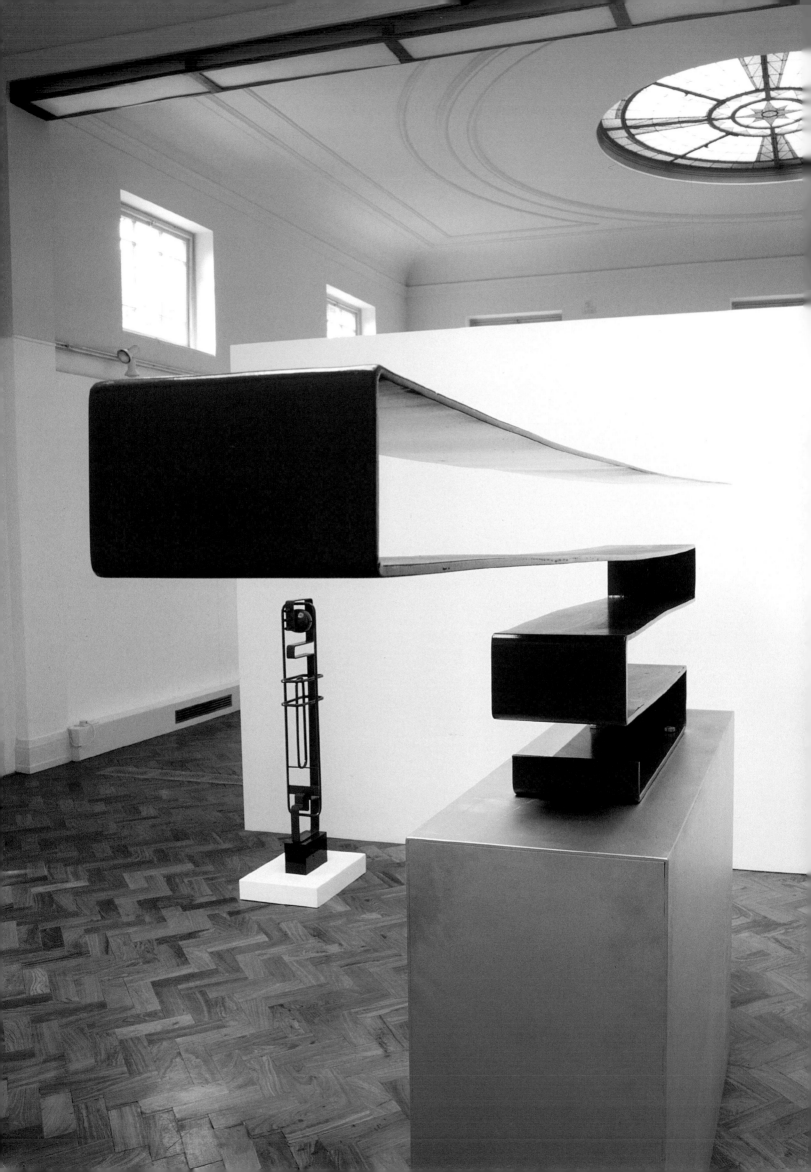

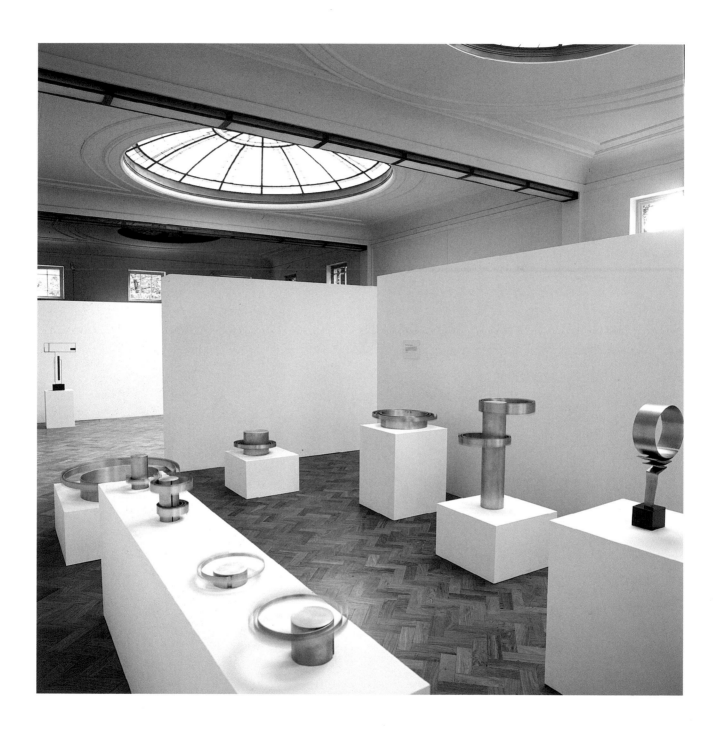

left. Avtarjeet Dhanjal, *Painted Aluminium Series*.
Installation view at Pitshanger Manor and Gallery, Ealing, 1997.
Photo: Jerry Hardman-Jones.

above. Avtarjeet Dhanjal, *Open Spiral Series*.
Installation view at Pitshanger Manor and Gallery, Ealing, 1997.
Photo: Jerry Hardman-Jones.

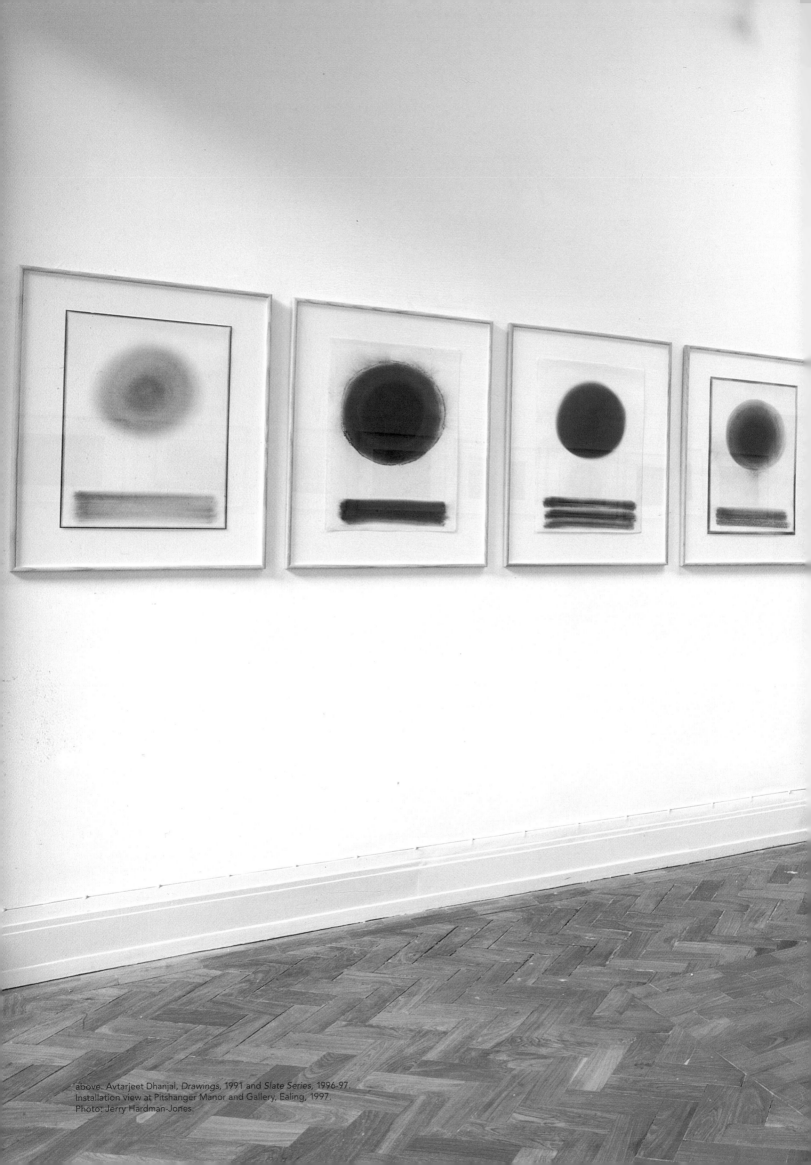

above: Avtarjeet Dhanjal, *Drawings*, 1991 and *Slate Series*, 1996-97.
Installation view at Pitshanger Manor and Gallery, Ealing, 1997.
Photo: Jerry Hardman-Jones.

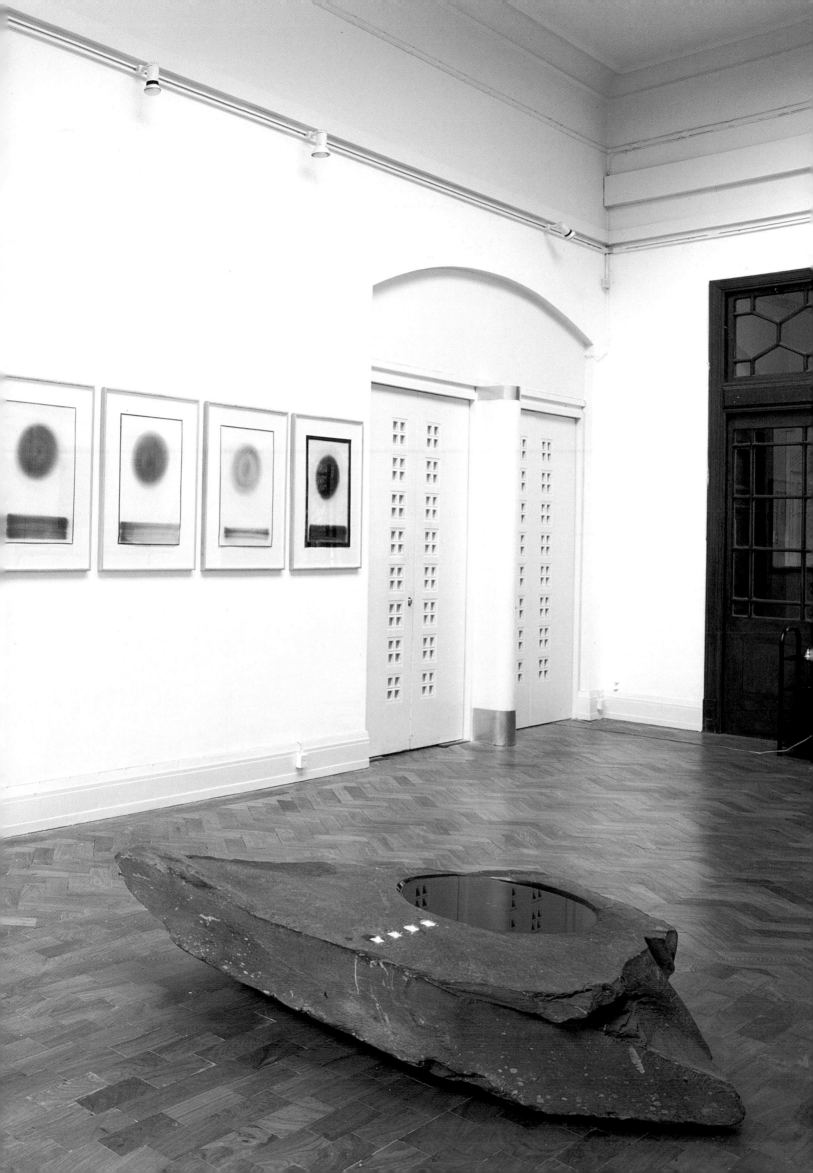

NOTES

1 Rasheed Araeen, *The Other Story: Afro-Asian Artists in Post-war Britain*, exhibition catalogue (London: South Bank Centre, 1989).

2 One of the criticisms of *The Other Story* was that it omitted many significant South Asian artists who did not fall into the agenda of political/confrontational work.

3 Interviewed Febuary 1997.

4 In particular, *Globalisation and The Region: Explorations in Punjabi Identity*, eds. Pritam Singh and Shinder S. Thandi, (Coventry: Association for Punjab Studies UK, 1996).

5 Interviewed Febuary 1997.

6 *Beyond Frontiers: contemporary British art by artists of south asian descent* (sic), eds. Amal Ghosh, Juginder Lamba and Antonia Payne. Due to be published in 1997/98.

7 Interviewed March 1997.

8 Interviewed March 1997.

9 Interviewed February and March 1997.

10 Interviewed Febuary 1997.

11 First performed in 1994 by Chandica Arts Company.

12 Interviewed February 1997.

13 A series of interviews with the artist (and also with his family) was carried out in February and March 1997.

14 Tagore's fusion of different cultural aesthetics within a contemporary style was enormously influential upon generations of Indian artists.

15 One wonders what would have happened had Dhanjal gone to Bengal where he would undoubtedly have received a more enlightened art education than in Chandigarh. However, for a concise and illuminating survey of art schools in relation to sculpture, see Janak Jhankar Narzary's 'Sculpture in Art Schools — 1850 -1950', *Nandan: An Annual of Art and Aesthetics*, Department of History of Art, Kala Bhavana, Visva Bharati, vol.XIV, 1994, pp.31-40.

16 The phrase comes from Sunand Prasad in *Le Corbusier: Architect of the Century* (sic), eds. Michael Wilson and Victoria Wilson (London: Arts Council of Great Britain, 1987), p.279.

17 Ibid.

18 Kanwal Dhaliwal interview, op.cit. He noted that the positive elements of coming to the city were 'meeting new friends', and a museum that was 'rich in Gandhara sculpture'.

19 Ranbir Kaleka interview, op.cit. He also noted that 'architectural configurations of modernity don't make you modern but they force you to live in a different way'.

20 Charles Jeneks has summarised these in *Le Corbusier and the Tragic View of Architecture*, rev. ed., (London: Penguin, 1987), p.281f. Former students of Chandigarh like Kaleka, Dhaliwal and Dhanjal have confirmed these comments, often forcefully. To give but one example: Dhaliwal noted that whereas at least the British studied the climate of the country, Le Corbusier ignored the fact that temperature rises can be of the order of fifty degrees centigrade and that no heating or cooling is required.

21 All unacknowledged quotations come from interviews with the artist.

22 Interview, op.cit. Both Dhanjal and Kaleka remarked on the lack of aesthetic awareness amongst certain lecturers.

23 Interview, op.cit.

24 Interestingly, over ten years later, Dhanjal, in a brief article entitled 'Situation in Punjab', *Report of a Study-Tour*, (London: Friends of Punjab, Spring 1978), p.6 notes that before Partition, the Punjab had produced a number of good sculptors and painters like Dhanraj Dhagat (sic), S.L. Prasher and B.C. Sanyal.

25 In 1970 he produced two large-scale pieces in steel (one painted red, the other steel grey) which he took to the National Gallery of Art in Delhi where they bought work once a year. According to Dhanjal the curator was amazed as he rarely saw steel works, and this was the first time that anyone had brought large-scale steel pieces to the museum. Dhanjal, who had gone out on a limb financially to make the work, was shattered when the purchase committee rejected them. One of the works was subsequently bought by the Lalit Kala Akademi, New Delhi.

26 Norbert Lynton in *Lalit Kala Contemporary*, New Delhi, no.4, April 1966, pp.8-10.

27 According to the artist, several large-scale versions of these works were produced, the whereabouts of which are unknown.

28 He had brought c.4 carvings with him plus two or three bronzes. The bronzes were made in the artist's fourth year at college. He had brought clay pieces to people who cast in copper and bronze but Muslims were prohibited to cast figurative work. He was sent to a young Muslim who didn't care!

29 Although Dhanjal had a desire to be urbanised, it is clear in retrospect that his journey, in part, was that of a return to a harmony with nature. Even in terms of his own lifestyle he moved from a Punjab village to Delhi, Chandigarh, Nairobi and London before finally settling in a small Shropshire village.

30 Two of the smaller aluminium pieces, *Aerial 1* and *Aerial 2* were exhibited in the *National Exhibition of Art*, Lalit Kala Akademi, New Delhi, 1973 for which there is an unpaginated catalogue. They were bought for the collection of the Punjabi University, Patiala.

31 Dhanjal seems to have had a series of exhibitions while he was in Africa. It is likely that they were small-scale and of little importance, featuring drawings, and possibly paintings. An early CV gives the following: Kennedy Memorial Hall, Hailie Selassie University, Addis Abbaba; City Library, Lusaka, Zambia; Indian Sports Club, Balantyre, Malawi; Tanganyika Library Exhibition Hall, Tanzania Art Society, Dar-es-Salaam, Tanzania, 1971; India House Library, Nairobi, Kenya.

32 In 1993. Juginder Lamba was the Director of the festival. The catalogue for the exhibition *Meeting Point* (Wolverhampton: Wolverhampton Art Gallery, 1993) has a brief introduction by Dhanjal who suggested the idea for the show, and an essay by Brendan Flynn. The show aimed to explore the cultural values and heritage of India and Pakistan in relation to the work of second generation Asian artists in Britain.
See also Cary Rajinder Sawhney (curator), 'Transition of Riches', *Transition of Riches*, exhibition catalogue (Birmingham: Birmingham City Museum and Art Gallery, 1993), pp.6-12. This essay explores various aspects of the British South Asian artists' experience.

33 See *Punjabi Lok Kala: Report of Study-Tour*, (London: Friends of Punjab, 1978). Avtarjeet was the governing spirit behind the tour, co-organized it and wrote part of the report.

34 Dhanjal knew of Caro's work. He saw a Caro exhibition in 1974 (presumably the one-man show *Table Sculptures* at Kenwood House in London) but Caro's notion of welding as essentially a form of an additive and thus collage element was foreign to Dhanjal. Dhanjal did try to work in welded steel but soon gave up.
For an indication as to the other line of development in British sculpture, it is instructive to look at the Tate Gallery's 1965 exhibition *British Sculpture in the Sixties* with its lineage of Adams, Armitage, Aryton, Butler, Caro, Chadwick, Dalwood, Frink, Martin, McWilliam, Moore, Paolozzi, Turnbull et al. The point is cogently made in Penelope Curtis's survey *Modern British Sculpture*, (Liverpool: Tate Gallery, 1988), p.109. Oddly enough, for a sculptor whose work reveals a marked conceptual bent, Dhanjal seems to have ignored the conceptual art of the sixties and seventies, and for that matter, to have ignored those artists like Gilbert and George who, at the time he was studying, were introducing a marked theatrical/performance element into English art.
See also Tim Scott and Alan Gouk, 'The Saint Martin's Affair: 'Gone too far'', *Artscribe*, no.42, August 1983, pp.30-38.

35 Ibid.

36 From the interview with Peter Fink, op.cit. Fink was a sculptor and part-time teacher at the college when Dhanjal was there.

37 Of course he was not alone in having difficulties. Dhanjal referred to another student who subsequently left the course and returned home.

38 Dhanjal did however relate to some of the sculptures of Philip King, possibly because of the bodily sensations generated by his unexpected arrangements of forms. This may have suggested a 'natural' relationship to him as opposed to the prevailing notions of 'unlikeness to nature' in the work of Caro and others. Dhanjal also responded to some of Annesley's paintings (though not his sculptures).

39 His few steel sculptures of the period were translations from the aluminium in exactly the same way as his wooden and stone carvings were translations from the plaster.

40 See, for example, William Tucker's pamphlet *Space Illusion Sculpture*, (London: Mains, 1974) which prints three of

his lectures. According to Dhanjal, he once told Tucker: 'When I listen to you, I think I understand you, but at the end of the day there's nothing left to take home'.

41 Dhanjal seems to have responded to only a few of the students in terms of their work. He cites the German Gerd Zwing whom he still keeps in contact with, and the Japanese sculptor Hiroshi Mikami who was to be one of the group who accompanied the artist on his study-tour to the Punjab in 1978.

42 Jacques Rangasamy, 'Mirror, Mirror On The Wall', essay in the unpublished collection, *Beyond Frontiers*, op.cit., p.6. It is unclear as to whether these comments are based on an interview with the artist.

43 Although Dhanjal himself never directly stated this in interview, he made reference to occasions when he felt himself excluded from certain activities.

44 Lamba interview, op.cit. In an article based on an interview with the artist, Arpana Cour remarks that 'The British are curiously hostile to contemporary Asian artists. They shrug off contemporary art in the Third World as a second-hand copy — and a bad one — of Western art, and refuse to see it on its own merits', 'A Punjabi Sculptor in London', *The Indian Express*, India, 11 November 1978.

45 Rangasamy. op.cit. p.6.

46 Of the various statements that I have found, many of them undated, I have used one given out at an exhibition of the aluminium pieces at Dudley Castle in 1975 and a similar statement, written for a proposed film on his work by Elizabeth Ledward (Kozmian), both in my possession.

47 Ibid.

48 For example, he seems to have bypassed artists such as Gunther Uecker, Julio Le Parc, Takis, Nicolas Schoffer, Jean Tinguely, etc.

49 The economy of Dhanjal's work is a case of parallel development. He certainly knew photographs of minimalist work — it would have been difficult to avoid Morris, Judd, Le Witt and Andre for example — but the movement's aims were distanced from him.

50 James Turrell is the only artist whom I have heard the artist refer to approvingly.

51 'My photographs go parallel to my sculptures in their two-dimensionality. They are not objects like sculptures, nor are they photographs of objects, rather they are recordings of the phenomenon that nature creates for me, when I am there to witness it'. Artist's statement, Dudley Castle Exhibition, 1975.

52 There was no catalogue but an information sheet was issued and various photographs exist of the work in situ. Alcan arranged the exhibition.

53 There are various versions of this story. According to *The Other Story*, op.cit. p.46, Avtarjeet was 'disturbed by the attitude of the workers...[and] shocked to find a few years later that all his work had been bulldozed into scrap'. Whatever Dhanjal's relationships with the Alcan workers, it is clear that he had an excellent relationship with Head Office in London as they continued to support him for a very long time. They offered him facilities to remake the work but he made new work instead which became the Warwick University sculptures. Furthermore, a trip to the scrap yard recovered a number of the works which were subsequently shown in the St Martin's show. It is possible that provincial Alcan executives considered art to be a waste of time...

The exhibition at Gallery 27 was in Tonbridge, Kent, 8-31 May 1976. A poster catalogue was issued, depicting aluminium pieces from Chandigarh, St Martin's, and the Dudley exhibition. After the exhibition, Dhanjal had been given a grant by Alcan to travel in the USA and Canada. When he returned he had ten dollars in his pocket. An Alcan executive Jim Prowse arranged the exhibition for him.

54 Alcan had been negotiating to give the residency pieces to Warwick University when they discovered that most of them had been destroyed. They then gave Dhanjal the facilities to do new work specially for the university and donated the five sculptures to them in 1978. It seems that they also donated three of the smaller works, made in 1975, to Telford, as these works were sited in a man-made pool in Telford Square in the same year.

55 From a one-page artist's statement dated December 1995.

56 *Report of Study-Tour*, op.cit. p.3.

57 There are several of these sculptures in the artist's possession.

58 See Araeen, op.cit. p.51. Araeen's catalogue/exhibition was crucial in imprinting upon the art establishment the notion that Britain was a multicultural nation and that Black/Asian artists could not be written out of art history. It gave a necessary and long overdue voice to a submerged group. In retrospect though, it perhaps reinforced the stereotypes of gender, race and identity which were associated with Black and South Asian art, failing to let the art breathe by and of itself, perhaps unconsciously situating the work in a confrontational us-and-them politics of race.

59 Shelagh Hourahane, 'Home and Foundland: the Sculpture of Avtarjeet Dhanjal', *Third Text*, no.8/9, Autumn/Winter 1989, pp.165-172 (pp.171-2).

Hourahane's article is a very sympathetic account of the sculptor's work and is especially valuable for drawing attention to Kenneth Frampton's notion of 'the architecture of resistance' [a positive sense of space, a careful understanding of site, climate and the 'choreography of the human experience of movement, colour, light and texture'] which she relates to the public work.

60 This is not such an oxymoron as it seems. In Indian terms, the sacred does not have to be seen in terms of *religion*. As Charles Correa, amongst others has pointed out, in 'The Public, The Private, and The Sacred', *Daedalus: Another India*, Autumn 1989, pp. 93-113 (p.95), as Europe increasingly distanced itself from religion, Picasso, Matisse, Stravinsky, Le Corbusier et al. accessed the primordial to find the sacred. It can, of course, be argued that Dhanjal was influenced by the spiritual aspect of early European modernism but it is much more likely that he was not.

61 Rangasamy, op.cit. The author's unpublished paper is a philosophical one, dealing broadly and valuably with a number of issues in the work. It rather uncritically accepts a chronology of the early years, presumably based on interview, which is markedly incorrect.

62 Peter Fink co-organised the symposium which took place between 11 February and 23 March 1980 at Punjabi University, Patiala. It was billed as being co-organised by the Friends of Punjab in collaboration with the Education Department, Punjab and the Punjabi University.

63 An Austrian sculptor widely regarded as the father of the symposium movement.

64 See Malcolm Miles, 'Location/Dislocation', *Art and the City*, ed. Malcolm Miles, (Portsmouth: University of Portsmouth, 1995), p.5.

Incidentally, this publication contains a short but extremely useful annotated bibliography on Public Art. The introduction to this publication, presumably written by Miles, is a cogent and eloquent comment on the need to relate art to its siting and 'to see a site as not just a physical space. Although buildings, parks and sculptures might begin as a design on white sheets of paper, they are experienced both physically and psychologically, create both an environment and an ambience; all streets, squares and nooks and crannies of the urban landscape are full of personal associations, memories and values, positive or negative, which condition feelings about those places' (p.3).

65 There is a substantial literature on Indian temples. I have taken my references from Charles Correa (op.cit), Pierre Ramback and Vitold de Golish, *The Golden Age of Indian Art* , (London: Thames & Hudson, 1955), A. Goswami, ed., *Indian Temple Sculpture* , (Bombay: Lalit Kala Akademi, 1956), Stella Kramrisch, *The Art of India* , (London: Phaidon Press, 1955) and W. Zwalf, ed., *Buddhism: Art and Faith*, (London: British Museum Publications, 1985), the last of which is particularly useful for a discussion of the *stupa*, the burial mound which is the ancestor of the temple.

66 In Dhanjal's sculpture at Punjabi University, Patiali, the weathered rock encased by railways is the sanctuary, the rock being the equivalent of the *lingam*; the pathway is the rectangular hall, while the open porch is technologically cut and imprisoned block. First of all in his work at Chandigarh in 1991, and then in his work at Maltings, 1993f.

67 Correa, op.cit, p. 93f.

68 Ibid.

69 Suzi Gablik, unaware of Dhanjal's work, advanced this idea in *The Re-enchantment of Art*, (London: Thames & Hudson, 1991).

70 As in the work for Banbury (1981), Forma Viva (1982) and Margam (1983).

71 In June he showed colour photographs of the kind already mentioned in the *Sala d'expocisions del FAD*, Barcelona; in September, at Heimat Museum in Springe, Germany he exhibited photographs and a number of the resin pieces while in November, at the Galeria Spectrum in Barcelona he exhibited his photographs.

72 Peter Fink had suggested that the two artists work together on a project back in 1979 and he had proposed it to Cherwell District Council. He had invited the Council to become involved with the Arts Council of Great Britain and Alcan (their research lab was at Banbury and 1981 was their fiftieth anniversary).

73 The two quotations are from Maryiln Carr's article 'art in public places' (sic), *Southern Arts*, no.12, January/February 1982, pp.2-3 and 9. Alcan provided facilities for 'welding, forming, machining and anodising'.

74 Dhanjal's final exhibition that year was at Galerie Werkoff, Bissendorf, West Germany where he showed drawings, a number of the stone and aluminium pieces, and also created an installation which was a version of that made in Yugoslavia, only bounded with aluminium strip. The Forma Viva symposium took place at Kostanjevica Na Krki, Yugoslavia between 2 July and 3 September 1982. The participants were Karl Ciesluk, Etsuo Hori, Dora Kovacevic, Carlos Medina and Franz Weickmann as well as the artist.

75 Quoted in Avtarjeet Dhanjal, 'Forma Viva', *Art Monthly*, no.65, April 1983, p.21.

76 The sculptor remarked that when you sit inside the well, you have a wonderful view of the sky, isolated from the rest of the world: 'That's what makes it sculpture for me'.

77 Neil Beecham, 'Setting the Art World Alight', *Yorker*, Leeds, August 1983, p.13. The article continues, 'First there were the 21 bags of sand which arrived on the doorstep. Then there was the pyramid which appeared in one of the training workshops and the jets of flame leaping forth from beneath a bed of sand...'

78 Avtarjeet Dhanjal, 'Fire as Sculpture Material in My Work Since 1983', April 1985, unpublished.

79 Ibid.

80 *48 Torches* is divided into three, adapting to a different ground layout. Both use York sandstone and the yellow polyethylene studs. Ironically, these two works provide the perfect demonstration of technology ruining a good art idea. Dhanjal needed to harness gas/fire. Technical requirements forced him to opt for a polyethylene replacement. He himself said that you can't replace one material with another. These works prove it.

Dhanjal participated in various exhibitions during 1983. In *Views of Horizons*, Yorkshire Sculpture Park, where he also participated in an International Symposium, he exhibited the Telford Park sculpture and in the Mappin Art Gallery's touring exhibition *Artist in Industry* (an essay by James Hamilton makes reference to Dhanjal on p.14 of the catalogue) which

started in Sheffield, November 1983, four works are cited: *48 Torches* (on show in Weston Park, outside the gallery); *Flame Line* (sand and gas flame), *Ten Candles* (stone and gas flame) and *Flame Line Pyramid* (sand and gas flame).

81 The Temple complex, which is the spiritual centre of the Sikh religion, was visited by Avtarjeet's study group in 1978. The study report (op.cit.) prints a photograph of the complex (p.29): open space, colour, architectural forms, a complex which seems to float in the midst of a blue lake, conjuring up a mood of meditation in visitors (see p.30). According to Inder Malhotra in *Indira Gandhi: A Personal and Political Biography*, (London: Coronet, 1989), pp.16f., Indira Gandhi gave the decision 'to order the troops to flush the terrorists out of the Golden Temple', not because of emnity for the Sikhs whom she regarded with great affection, but 'this is not how the Sikhs in general and extremists and terrorists in particular saw things'. She was assassinated on 31 October 1984 by her Sikh bodyguards.

82 See Victor Volland, 'Artist Strives to Stress Peace Through Sculpture', *St. Louis Post-Dispatch*, 28 March 1985 for a brief account of his activities.

83 Ibid.

84 Ibid.

85 Bill Lonsdale, 'Art in Action', *Landscape Design*, October 1987, pp. 24-27.

86 Unfortunately elements of this structure have been vandalised. The archway no longer exists, nor does the semi-circular wall. The colonnade, shamefully neglected, remains creeper-less! Despite the destruction, it is still an impressive piece of work.

87 "...sly playful humour" is invoked in relation to the *topos* of the colonised 'servant' who always gets the better of his masters, as in Anglo-Irish and Anglo-Indian literature.

88 This translation was Dhanjal's and seems to be in the spirit of the Sikh separatist movement. A more literal translation would be 'Truth shall prevail' or 'The pure shall reign'. The phrase is a Sikh biblical one.

89 I am thinking of the square in front of Birmingham Art Gallery and Museum, for example.

90 *Il Sud del Mondo* was at Galleria Civica D'Arte Contemporanea, Marsala, Sicily (14 February–14 April 1991) and was curated by Carmelo Strano. My only knowledge of the Japanese show is an article written by Shelagh Hourahane, 'Fire, Water and Stone', *Ryusei Ikebana*, Japan, August 1991, pp.13-17. Unfortunately it is only written in Japanese.

91 This was one of a series of sculptural projects involving various Indian artists. See Rita Sharma, 'A Criminal Neglect of Sculpture', *The Tribune*, 2 June 1994, p.9. The article attacks the neglect of a whole series of sculptures, including Dhanjal's.

92 Quoted in Sharma, op.cit.

93 Robert Camlin, 'The Language of the Maltings', *Cardiff Bay*, issue 4, Summer 1995, pp.20-23. Ironically the article is

headed by a quotation from Ruskin: 'The measure of any great civilisation is in its cities and a measure of the city's greatness is to be found in the quality of its public places, its parks and squares'. Ruskin, of course, dismissed Indian civilization out of hand.

94 Camlin Lonsdale created the masterplan. Dhanjal comments that 'having a landscape architect as the main consultant means that your contribution as an artist doesn't make much difference'.

95 Camlin, op.cit., p.21.

96 Ibid.

97 I Ching is used as the basis for 'feeling the place. You organise sleeping, for example, according to the energy of a place'.

98 This may possibly indicate a rupture in the relationship between the landscape architect team and the sculptor; or simply a severe lack of finance.

99 See *Meeting Point*, op. cit. p.4. Araeen, amongst others, notes that such works are usually produced by artists who break into the establishment - at least initially. It is worth noting that Dhanjal researched and co-selected the Indian element of the *Meeting Point* show in which the second generation of British Asian artists were placed side by side with the Indian generation of the same age.

100 *Needle* (1984-5), *Valley of Lights* (1984-5), *Open Circle* (1984-5), *Upper Level 1* (1984-5) and *Upper Level 2* (1987).

101 The work for Cartwright Hall was co-commissioned in 1996. This marked a new development in the slate pieces with the introduction of a water element as opposed to the candles. The other four works were untitled at the time of writing, except for *The Candle* which was exhibited in *Freedom*, the Amnesty touring show curated by Angela Kingston in 1996.

102 Avtarjeet Dhanjal, autobiographical writings, (unpublished). In their current state the writings consist of four short chapters headed The Village, Village 2, Village 3 and The Town.

103 Ibid. This passage almost exactly mirrors the idea for the Cartwright Hall piece in Bradford which uses a tapestry embroidered with small mirrors which reflect in water like a starry night.

104 The stonemason Stefan Giggs remarked to me that when he first heard about the steps he 'thought it was naff, about little people and the like, but when you see it, it's breathtaking. It works!'.

105 One may think of W.B. Yeats and his gyres, the Hindu parallel of the wheel (Chakara) or of Tantra, unwinding outwards into the middle.

106 Interview with C.B. Watson, op.cit.

SELECTED BIBLIOGRAPHY

In addition to texts cited in the notes, the following have been found useful:

Andrea, Christopher. 'Worlds Meet in Dhanjal's Art'. *Christian Science Monitor* , 7 January 1991, p10.

Chandigarh Artists (exhibition catalogue). Chandigarh: Government Museum and Art Gallery, 1987.

Contemporaries: A Documentary. London: Channel 4, 5 March 1987.

Dhanjal, Avtarjeet. *Autumn Leaves No.2* (poster). London: Punjab Publications, 1974.

First International Sculpture Symposium (exhibition catalogue). Patiala: Punjabi University/Friends of the Punjab, 1980.

Freedom (exhibition catalogue). Edinburgh: Amnesty International UK, 1995.

Il Sud del Mondo: l'Altra Arte Contemporanea (exhibition catalogue). Milan: Mazzotta, 1991.

Khan, Asif. 'Sculptures that sway in the breeze' (sic). *New Delhi Morning Echo*, 3 October 1978, p.3.

National Exhibition of Art (exhibition catalogue). New Delhi: Lalit Kala Akademi, 1973.

Open Studio. Interview by Harold Fouks, BBC Radio Shropshire, 10 November 1988.

St Martin's South Bank Sculpture (exhibition catalogue). London: St Martin's School of Art, 1977.

Sculpture in a Country Park: An Outdoor Exhibition in the Grounds of Margam (exhibition catalogue). Margam: Welsh Sculpture Trust, 1983. Dhanjal features on pp.84-87.

Sharma, Rita. 'A Sculptor's Regret' (sic). *The Sunday Tribune*, 5 February 1984, p.16.

Singh, Chris Mooney. 'Towards cultural highway' (sic). *The Tribune* (Saturday Plus), 29 October 1994, pp.1-4.

Smith, Julia. 'Window on the East'. *Perfect Home*, June 1994, pp.52-57.

Stories of Art: Avtarjeet Dhanjal. BBC1 documentary, 19 September 1993.

The Other Story: Afro-Asian Artists in Post-war Britain. London: South Bank Centre, 1989 (curator: Rasheed Araeen).

ADDITIONAL READING

Appasamy, Jaya. *An Introduction to Modern Indian Sculpture*. Delhi: Indian Council for Cultural Relations/Vikas Publications, 1970.

Appasamy, Jaya. 'Contemporary Indian Sculpture'. *Lalit Kala Contemporary*, no.10, September 1991, pp.1-6.

Asian Art Now (exhibition catalogue). Hiroshima: Hiroshima City Museum of Contemporary Art, 1994.

Bammer, Angelika (ed.). *Displacements: Cultural Identities in Question*. Bloomington: Indiana University Press, 1994.

Beyond Destination: film, video and installation by South Asian artists (sic) (exhibition catalogue). Birmingham: Ikon Gallery, 1993 (curator: Ian Iqbal Rashid).

Bickelmann, Ursula and Ezekiel, Nissim (eds.). *Artists Today: East-West Visual Arts Encounter*. Bombay: Marg Publications, 1987.

Black Art: Plotting the Course (exhibition catalogue). Oldham: Oldham Art Gallery/Wolverhampton Art Gallery/Bluecoat Gallery Liverpool, 1988 (curator: Eddie Chambers).

Chamatkara: Myth and Magic in Indian Art (exhibition catalogue). Calcutta: Centre of International Modern Art, 1996.

Chambers, Eddie; Joseph, Tam and Lamba, Juginder. *The artpack: a history of Black artists in Britain* (sic). London: Haringey Arts Council, 1988.

Checketts, Lynda. 'British Art in a Century of Immigration' introduction and papers from the conference 'British Art in a Century of Immigration' (Norwich, 15-16 March 1991). *Third Text*, no.15, Summer 1991, pp.5-10f.

Corbett, Jim. *My India*. Madras: O.U.P, 1952.

Crill, Rosemary; Skelton, Robert; Stronge, Susan and Topsfield, Andrew. *Facets of Indian Art*. London: Victoria & Albert Museum, 1986.

Dalmia, Yashodhara. 'That brief thing called modern' (sic). *Art and Asia Pacific*, vol.2, no.1, January 1995, pp.88-91.

Gilroy, Paul. 'Art of Darkness: Black Art and the Problem of Belonging to England'. *Third Text*, no.10, Spring 1990, pp.45-52.

Graubard, Stephen R. (ed.). *Daedalus: Another India*. Proceedings of the American Academy of Arts and Sciences, vol.118, no.4, Autumn 1989.

Grewal, J.S. *The Sikhs of Punjab*. Madras: O.U.P., 1991.

Gupta, Sunil (ed.). *An Economy of Signs: Contemporary Indian Photographs*. London: Rivers Oram Press, 1990.

India Songs: Multiple Streams in Contemporary Indian Art (exhibition catalogue). Sydney: Art Gallery of New South Wales, 1993 (curator: Victoria Lynn).

Ions, Veronica. *Indian Mythology*. London: Hamlyn, 1967.

James, Josef (ed.). *Contemporary Indian Sculpture: the Madras Metaphor*. Madras: O.U.P., 1993.

Kapur, Geeta. *Contemporary Indian Artists*. New Delhi: Vikas, 1978.

Kapur, Geeta. *Pictorial Space: A Point of View on Contemporary Indian Art*. New Delhi: Lalit Kala Akademi, 1978.

Kapur, Geeta. *Contemporary Indian Art* (exhibition catalogue). London: Royal Academy of Arts/Indian Advisory Committee, Festival of India, 1982.

Kapur, Geeta. 'When Was Modernism in Indian Art'. *Journal of Art and Ideas*, no.27/28, March 1995, pp.105-126.

Khan, Naseem. *The Arts Britain Ignores: The Arts of Ethnic Minorities in Britain*. London: Community Relations Commission, 1976. (A report for the Arts Council of Great Britain, Calouste Gulbenkian Foundation and Community Relations Commission.)

Machado, Alvaro. 'Acontece'. *Folha de São Paolo*, 6 October 1990, p.f11.

Mackenzie, Donald. *Indian Myth and Legend*. London: Gresham, (n.d.).

Madan, T.N. 'Religion in India'. *Daedalus: Another India*, vol.118, no.4, Autumn 1989, pp.115-146.

Mannering, Douglas. *Great Works of Indian Art*. Bristol: Parragon, 1996.

Marg, Bombay, vol.21, no.2, March 1968. (A special issue on contemporary world sculpture.)

Mercer, Kobena. 'Black Art and the Burden of Representation'. *Third Text*, no.10, Spring 1990, pp.61-78.

Mitter, Partha. *Much Maligned Monsters: A History of European Reactions to Indian Art*. Chicago: University of Chicago Press, 1992.

Mosquera, Gerardo (ed.). *Beyond the Fantastic: Contemporary Art Criticism from Latin America*. London: Institute of International Visual Arts, 1995.

Nandagopal, S. 'As a Sculptor looks at it' (sic). *Lalit Kala Contemporary*, March 1991, pp.26-32.

Narzary, Janak Jhankar. 'Indian Sculptors in International Context'. *Nandan*, vol.X, 1990, pp.44-55.

The New South: Contemporary Painting and Sculpture from South India (exhibition catalogue). London: Kapil Jariwala Gallery, 1996.

Parimoo, Ratan. *Studies in Modern Indian Art*. New Delhi: Kanak Publications (Books India Project), 1975.

Pawley, Martin. 'Changer of the garde' (sic). *The Guardian*, 5 March 1989, p.12.

Powell, Richard J. *Black Art and Culture in the 20th Century* (sic). London: Thames & Hudson, 1997.

Ratej, Olga. 'Pri Kiparjih, Ki Obdelujejo Kra Kovske Hrste'. *Delo*, Ljubljana, p.21.

Ray, Pranabranjan. 'Towards a political sociology of modernity and modernism' (sic). *Nandan*, vol.XI, 1991, pp.20-29.

Roberts, John. 'Indian Art, Identity and the Avant-garde: the Sculpture of Vivan Sundaram'. *Third Text*, no.27, Summer 1994, pp.31-36.

Sandhu, Dr. C.S. Chan. *The Sikh Heritage*. Middlesex: Dr. C.S. Chan, 1984.

Segal, Ronald. *The Crisis of India*. London: Penguin, 1965.

Sihra, Kirpal Singh. *Sikhdom*. South Harrow: Sikh Commonwealth, 1985.

Singh, Khuswant. *A History of the Sikhs*, vol.1, Madras: O.U.P., 1991.

Sundaram, Vivan. 'A Tradition of the Modern'. *Journal of Arts and Ideas*, no. 20/21, March 1991, pp. 33-40.

Tagore, Sundaram. 'Towards Identity'. *Asian Art News*, vol.5, no.6, November/December 1995, pp.54-57.

Tandon, Prakash. *Return to Punjab 1961-1975*. London: Berkley, 1981.x

Trophies of Empire (exhibition catalogue). Liverpool: Bluecoat Gallery/ Liverpool John Moores University, 1994.

Zei, Lada. 'Hrast, Posekan Za Vecnost'. *Teleks*, Ljubljana, 19 August 1982, p.20-21.

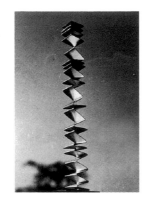

CHRONOLOGY

c.(1939)
1940 Born 10 April at Dalla, Punjab, India.

1945-55 Schooling at Government School Mallah, Punjab.

1955-58 Works in his father's trade as a carpenter and blacksmith.

1958-65 Vehicle body-builder, then sign-painter, both locally and in Delhi.

1965-70 Chandigarh College of Art. Two years foundation, then three years specialisation. Studies painting first of all but swiftly transfers to sculpture.
Produces figurative work in wood, clay, plaster, bronze and stone; abstract work in steel, aluminium and plywood.
First wood carving bought by Chandigarh Museum.
Participates in All-India Fine Arts Society, Amritsar, India, and study–tours of India arranged by college during this period.
First solo exhibition at Government Museum, Chandigarh in January 1969. Work bought for the collection of Chandigarh Museum.
Receives state award in sculpture from Lalit Kala Akademi, Punjab, India.
Special prize in sculpture from Lalit Kala Akademi, 1970.
Obtains diploma in sculpture and clay-modelling (BFA), May 1970.

1971 Leaves Punjab for Africa. Travels in Kenya, Tanzania, Malawi, Zambia and Ethiopia. Studies the Western influence on traditional woodcarving among the younger generation.
Small solo exhibitions at Kennedy Memorial Hall, H.S. University, Addis-Ababa, Ethiopia; City Library, Lusaka, Zambia; Indian Sports Club, Limbe, Blantyre, Malawi; Tanganyika Library, Dar-es-Salaam, Tanzania; and India House Library, Nairobi, Kenya (drawings and charcoal sketches).
Participates in *National Exhibition of Art*, New Delhi and Gwalior, India.

1971-73 Teaches sculpture at Kenyatta University College, Nairobi, Kenya, July 1971 to December 1973.
Produces work in aluminium which is a development of the Chandigarh aluminium and steel sculptures.
Participates in Royal Society of Artists, Birmingham, 1972.
Exhibition at Woodstock Gallery, London, May 1973.
Participates in *National Lalit Kala Akademi*, New Delhi, India.
Work bought by National Lalit Kala Akademi, New Delhi, India.

1974 Studies at Central Saint Martin's School of Art and Design (Advanced Sculpture course) in London.
Produces work in aluminium which is a development of the Chandigarh and Kenyan sculptures.
Produces maquettes for the Alcan works (1975) late in the year.
Produces some nature-based photographic work.
Short study-reel film is made of his aluminium sculptures.
Participates in *Concurso Internacional de Escultura*, Barcelona, Spain, August/September.
Works on African section of the Hieme-Becker *Encyclopedia of International Artists* (new ed.).

1975 Artist-in-Residence at Alcan Aluminium (UK), Tipton, January–December.
Produces large-scale spiral aluminium sculptures, "employing elastic element of metal with natural wind to induce perpetual movement".
Exhibition at Dudley Castle, Dudley, West Midlands, December.

1976 Travels in USA and Canada, sponsored by Alcan.
Grant from Arts Council of Great Britain for research project on Art and Industrial Relations.
Establishes residence in London.
Exhibition at Gallery 27, Tonbridge, Kent in May.

1977 Commissioned by Alcan, for a group of sculptures for the University of Warwick, Coventry.
Participates in St Martin's South Bank show.
Establishes non-profit making organisation 'Friends of the Punjab' for cultural exchanges.

1978 University of Warwick sculptures installed.
Co-organises a study– tour on the folk arts and crafts of the Punjab.
Participates in the tour and publishes a report on same.

1979 Sets up sculpture studio in London.
Travels in Spain and France.
Produces photographic work and sculptures using leaves, twigs etc., embedded in resin. Resin-based works start in Spain.

1980 Co-organises (with Peter Fink) the 'First International Sculpture Symposium' in Punjab, at Punjabi University, Patiala, India and produces first major outdoor sculpture, now in the collection of Punjabi University Museum.

1981 Commissioned by Cherwell District Council for a public sculpture at Bodicote House, Banbury, Oxfordshire (*Contribution*).
Sponsored in part by Alcan.
Solo exhibition of photographs at *Sala d'exposicions del FAD*, Barcelona, Spain in June.
Exhibition at Heimat Museum, Springe, Germany in September.
Solo exhibition of photographs at Galeria Spectrum, Barcelona, Spain in November.

1982 Participates in 'Forma Viva' sculpture symposium, former Yugoslavia and produces *Wayside Well* sculpture.
Uses sand for the first time when he produces his first installation, on a beach, *Walk Across Five Pyramids*.
Exhibition at Galerie Werkoff, Bissendorf, West Germany.

left. Avtarjeet Dhanjal, *Two Figures*. c.1966. Wood. Chandigarh.
centre. Avtarjeet Dhanjal, *Endless Column*. 1969. Aluminium. Chandigarh.
right. Avtarjeet Dhanjal, *Ten Candles*. NEGAS, Leeds.1983.

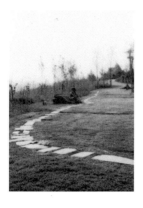

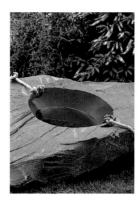

1983

Participates in *Maquettes for Public Sculpture* exhibition, Welsh Sculpture Trust.

83 Steps—site-specific sculpture for Margam Country Park, South Wales. Uses slate for the first time.
Artist-in-Residence at NEGAS (British Gas) via the 'Artist-in-Industry' scheme of Yorkshire Arts Association. Produces various works using fire, sand, stone and polyethylene, including outdoor sculpture for NEGAS Training College, Leeds; and *Flame Line Pyramid* installation.
Participates in *Artist-in-Industry* touring exhibition, starting at Mappin Art Gallery, Sheffield.
Participates in 'International Sculpture Symposium' and *Views of Horizons* exhibition at Yorkshire Sculpture Park.
48 Torches erected in Town Park, Telford.

1984 Builds family residence in Chandigarh, India.

1985 Makes *Peacemaker* sculptural installation in Maryland Plaza for St. Louis Arts Festival, Missouri, USA.
Produces *Fifteen Floating Flames* installation, also using candles and fire, in Grand Basin, Forest Park, St. Louis, Missouri, USA.
Participates in the 'International Symposium of the Arts' (*Shaping the Future: Arts in the World of Crisis*) at Banff Arts Centre, Banff, Canada.

1986 Commisioned by and participates in National Garden Festival, Stoke-on-Trent (*Along the Trail*).
Valley Park Secondary School Residency, Wolverhampton.
Produces first major commision, entitled *Dunstall Henge (Peace Sculpture)* at Peace Green (formerly Francis Street), Wolverhampton.
Initiates the artists' group Artists' Concern.

1987 Appears in *Register of Artists and Craftsmen in Architecture*.

Exhibition at Horizon Gallery, 23 February–14 March.
Board member of the Public Art Commissions Agency, Birmingham (1987-88).

1988 Residency at Hill Crest School, Birmingham.

1989 Public sculpture for Senneley's Park, Birmingham.
Exhibits in *The Other Story: Afro-Asian Artists in Post-war Britain* at the Hayward Gallery, London (curator: Rasheed Araeen). Shows slate pieces for the first time: a major new development in his work.
Alcan spiral aluminium works re-made for *The Other Story* and later installed in the Town Square, Telford.

1990 Gives a series of ten lectures at the University of São Paulo, on the subject of the artist's role in the debate on the environment.
Produces *5000 Candles for Justice* installation for Museu de Arte Contemporana, São Paulo, Brazil, at Parque Ibirapuera.

1991 Commissioned by City of Chandigarh to produce an environmental sculpture in Chandigarh, India.
Travels in South India to study temple architecture.
Participates in *Il Sud del Mondo (The South of the World)* exhibition at Galleria Civica d'Arte Contemporanea, Marsala, Sicily.
Participates in *Encounters* exhibition, co-curated by Eddie Chambers, at the Usher Gallery, Lincoln, 29 June 29 September.

1992 Appointed by Cardiff Bay Develop-ment Corporation as one of the design team for the ten-acre site, Maltings Park, Cardiff, which he regards as "dealing with the need for a humane space and a conceptual piece of sculpture that will weave through the whole of the park".

1993 At work as sculptor on the large-scale Maltings Park project. Produces new synthesis of 'East' and 'West'.
Board member of South Asian Visual Arts Festival and Sampad.
Co-selector of *Transition of Riches* exhibition for which he travels to India.

1994-95 Initiates The Shropshire Millennium Project and The Shropshire - Punjab Arts Link.
Contributes article to *Punjabi Artists in Shropshire Schools* catalogue (Shropshire County Council Education Department).
Participates in *Double Vision: Portraits of Shropshire Artists and their Work* exhibition.

1995 Board member of West Midlands Arts (and Adviser, Visual Arts Panel).
Participates in Amnesty International *Freedom* exhibition at Glasgow Art Gallery and Museum, Ormeau Baths Gallery, Belfast and City Gallery, Southampton.
Initiates The World Beyond 2000 (The World Symposium on the Role of the Artist in Shaping Histories and Imagining Futures).

1996 Co-commissioned by the Institute of International Visual Arts (inIVA) and Cartwright Hall, Bradford to make a piece of sculpture for the permanent collections of Bradford Art Galleries and Museums.

1997 First major solo exhibition at Pitshanger Manor and Gallery, curated and produced by the Institute of International Visual Arts (inIVA) in association with Pitshanger Manor and Gallery (8 August–20 September 1997).
At work as lead artist on Farm Park, Birmingham, a twelve–acre innercity project commissioned by the Public Art Commissions Agency for the City of Birmingham.
Exhibition at Buildwas Abbey, Shropshire in September/October 1997, an English Heritage project.

left. Avtarjeet Dhanjal, *Along the Trail*. National Garden Festival. Stoke-on-Trent.

centre. Avtarjeet Dhanjal, *Open Spiral Series*. c.1975-76. Photo: Jerry Hardman-Jones.
right. Avtarjeet Dhanjal. Photo: Claire Glasscoe.

Brian McAvera is an author, playwright and curator. He has had a number of plays published, transmitted and performed for stage, radio and television, of which the most recent was the acclaimed radio series *Picasso's Women* (Oberon Press, 1997). He is author of *Art, Politics and Ireland* (Open Air, 1989) as well as numerous exhibition catalogues. He curated the exhibition *Rolling Devolution: Current Scottish/Irish Art* for a Scottish Consortium in 1997 and is currently preparing a major Irish survey show for Poland in 1999.